POSTCARD HISTORY SERIES

French Lick and West Baden Springs

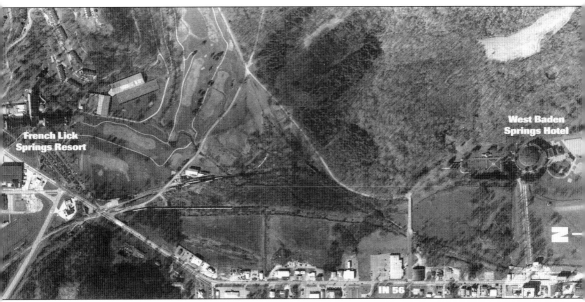

French Lick and West Baden, both located in Spring Valley, are separate incorporated towns under Indiana law. They have separate town governments and town services. Until 1935 there were separate post offices. The French Lick Post Office opened on November 26, 1847. The name was changed to West Baden on December 30, 1861, and then back to French Lick on May 17, 1865. The West Baden Post Office opened on December 30, 1861. The name was changed to West Baden Springs on September 1, 1935, but the office closed the same day. The town is now served by the French Lick Post Office.

On the front cover: The French Lick Springs Hotel is captured in this view in its final configuration. (Author's collection.)

On the back cover: The Water Wagon transported guests to several springs in the vicinity. (Author's collection.)

POSTCARD HISTORY SERIES

French Lick and West Baden Springs

John Martin Smith

ARCADIA
PUBLISHING

Published by Arcadia Publishing
Charleston SC, Chicago IL, Portsmouth NH, San Francisco CA

Printed in the United States of America

Library of Congress Catalog Card Number: 2007920810

For all general information contact Arcadia Publishing at:
Telephone 843-853-2070
Fax 843-853-0044
E-mail sales@arcadiapublishing.com
For customer service and orders:
Toll-Free 1-888-313-2665

Visit us on the Internet at www.arcadiapublishing.com

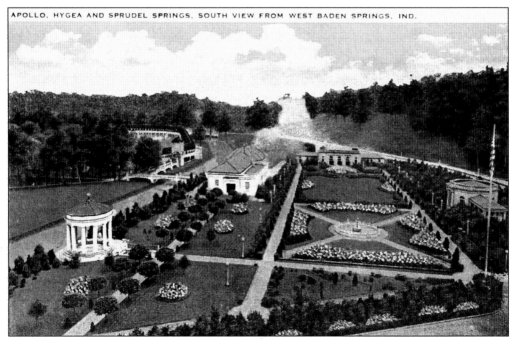

The Apollo, Hygeia, and Sprudel Springs and the bicycle track are shown from the porch of the hotel.

CONTENTS

ACKNOWLEDGMENTS

I am indebted to several people who have contributed to the production of this book. My wife, Barbara Clark Smith, has participated in the collection of these postcards for nearly 40 years. I thank her for her patient search through thousands of postcards at antique shows and antique malls to find those relevant to French Lick and West Baden Springs. My son and law partner, Thompson Smith, has made law office facilities available to assist in the production of this book. Lorene Thiele has done the computer input and organization, assisted by my secretary, Darlah Brennan. Craig Berndt and Bill Lock have provided research and encouragement. Arcadia editor Anna Wilson has assured getting the book into print in accordance with the high standards of Arcadia. The quiet behind-the-scenes efforts of a good editor always make an author look good.

This book is dedicated to Lee Sinclair and Ed Ballard, who lived the dream of the West Baden Springs Hotel; to Thomas Taggart Sr. and Thomas Taggart Jr., who lived the dream of French Lick Springs Hotel; to Reid Williamson, former president of Historic Landmarks Foundation of Indiana, who dreamed of the renaissance of the West Baden Springs Hotel and French Lick Springs Hotel; to state representative Jerry Denbo and the "Orange Shirts," whose dogged efforts induced the Indiana General Assembly to authorize Indiana's 11th casino at French Lick–West Baden; and to William and Gayle Cook, who provided the largesse to preserve and restore the historic West Baden Springs and French Lick Springs Hotels.

I am indebted to those photographers and merchants who had the foresight to create and distribute the original postcards. While postcards have a fleeting ephemeral quality to them, those pack rats who have collected and saved them have provided us a vision of these hotels that would have otherwise been lost after the click of the camera and the thunk of the postmark.

—John Martin Smith

INTRODUCTION

My first trip to French Lick–West Baden Springs was in 1967 to attend the Indiana State Bar Association Annual Convention, which was held at the French Lick Springs Hotel. I was awed by the hotel and its amenities. Continuing legal education sessions were held during the day in various areas of the hotel.

The evening banquets were elaborate. Eight guests were seated at each round table covered with white linen tablecloths. The china with the French Lick Springs crest was impressive. Being a farm boy from DeKalb County, I was not sure what to do with the array of flatware at each setting. The most memorable part of the banquet was the serving of the dessert. The house band struck up a rousing rendition of "When the Saints Go Marching In." I was prompted by a friend to watch the swinging doors—then eight African American waiters came dancing into the hall balancing huge trays of desserts on their heads. They each danced to their stations and deftly put the trays on their stand before serving the desserts. I shall always remember that presentation.

The keynote speaker was noted defense attorney F. Lee Bailey, who flew his private jet from Florida to French Lick. After he became airborne, he radioed the flight control tower and reported that he was flying to French Lick, Indiana. The air flight controller asked, incredulously, "French Lick What?"

As guests, we explored the hotel and its grounds and even had a drink of Pluto Water. The hotel was getting a bit "seedy" at that time, but this was overlooked by one who appreciated the building from a historical standpoint. As we left on Saturday, we were able to have a short tour of the West Baden Springs Hotel, then occupied by the Northwood Institute. This was the most impressive building I had ever seen. I was awed by the dome. The building was last used as a hotel in 1932, and many modifications had been done. However, the atrium and dome were original. As one interested in historic preservation and a collector of vintage postcards, I began acquiring images of the hotels. This collection is the basis for this book.

Springs Valley was a "happy hunting grounds" of the Native Americans for many centuries. The mineral springs were considered to be a gift from the "Great Spirit." Here the wild beasts of the forest were at peace with the Native Americans. French settlement occurred as early as 1729. George Rogers Clark named this area French Lick at an early date. The United States government reserved the area for salt springs, which were valuable in that era. The springs produced no salt, however, and the land became available for purchase. The springs were purchased by Dr. William A. Bowles in 1832. He built a hotel in 1840 and touted the springs for their medicinal and curative qualities. Although he leased the facilities at various times, he maintained ownership until his death in 1873.

Indiana's 1852 constitution and "Black Laws" prohibited African Americans from being brought into Indiana. He appealed his conviction to the Indiana Supreme Court, and the conviction was reversed on technical grounds. Dr. Bowles was proslavery and brought several African Americans into Indiana, including a woman named Polin. He was charged with a criminal offense and convicted. During the Civil War, Dr. Bowles was active in the Knights of the Golden Circle, a group that opposed the Civil War. He was tried for treason by a military court in the infamous Indianapolis Treason Trials. He was convicted and sentenced to "hang by the neck until dead." Pres. Abraham Lincoln had suspended the writ of habeas corpus so he could not appeal his conviction to a civil court. Shortly before the scheduled date of execution, then-president Andrew Johnson commuted the sentence, and Dr. Bowles was freed.

The 1876 atlas of Indiana stated that the springs "have long been deservedly popular for the cure of chronic afflictions of liver, dyspepsia, etc. They are delightful watering places, and have for many years been the chief summer resort for many of the health and pleasure seekers of Kentucky and the Western States. The situations are peculiarly pleasing in a wild and romantic section of the country, abounding in high hills and caves, and the grounds are handsomely located. The natural forest trees have been suffered to remain, and they are acknowledged by all who visit them to be the prettiest and best fitted up watering places in the State." The area was also noted for limestone quarries and the celebrated Hindostan Oil Whetstones, which were used to sharpen knives and cutlery.

There were several other owners between 1873 and 1891, when the hotel and grounds were sold to the French Lick Springs Company. Improvements were made over the years, but the building burned in 1897. West Baden Springs was originally called the Mile Lick, it being just a mile from French Lick. Dr. John A. Lane had leased the French Lick Springs Hotel from Dr. Bowles from 1846 to 1851. After his lease expired, Dr. Lane purchased the Mile Lick along with 770 acres of land. Within a year he built a hotel that was larger than the French Lick Springs Hotel. Thus, the friendly but fierce competition between these two resorts, within a mile of each other, began and existed until 1932. Dr. Lane leased the facilities to Hugh Wilkins in 1864. Dr. Lane assumed control in 1883 but soon sold out to a group of investors. Extensive improvements were made, but the hotel was again consumed by fire in 1902. At that time, Lee W. Sinclair became the sole owner.

By coincidence both hotels burned within five years of each other, but the flamboyant, visionary owners—Lee W. Sinclair owned the Mile Lick Hotel and Thomas Taggart owned the French Lick Springs Hotel—began a competition as to who could build the most magnificent hotel. Over the years, many famous persons have patronized the hotels—Steve Allen, Louie Armstrong, F. Lee Bailey, Larry Bird, Diamond Jim Brady, Al Capone, Bing Crosby, Bob Hope, George Jessel, Joe Louis, Ronald Reagan, Franklin D. Roosevelt, Babe Ruth, Harry Truman, and Lana Turner. In recent years, the town of French Lick has been nationally recognized as the hometown of basketball great Larry Bird.

While postcards were not originally intended to document a town or place historically, I find the printed postcards are a great source of information that might not otherwise be available. I sincerely hope that my readers use these images and the text contained herein to appreciate the heritage of the French Lick Springs and West Baden Springs Hotels.

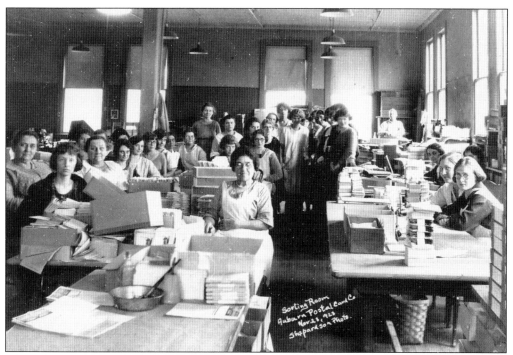

The Auburn Postal Card Company, located in Auburn, Indiana, was a major supplier of postcards in the United States. Female employees sorted and packaged postcards for shipment. Below are the employees of Auburn Postcard Manufacturing Company standing in front of the business.

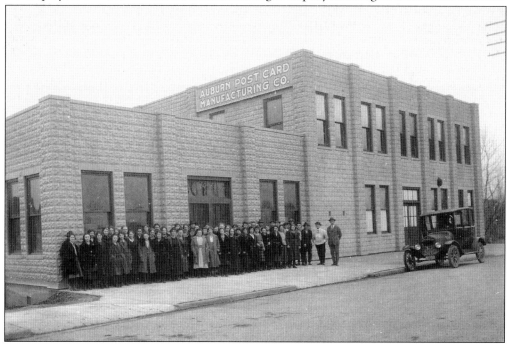

ALIAN GARDEN, FRENCH LICK, IND.

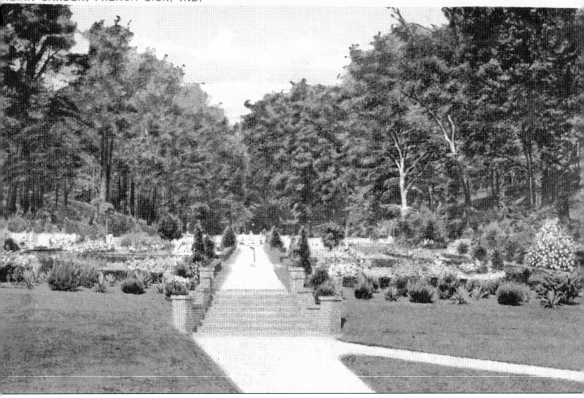

The Italian Garden in the French Lick Springs Hotel was surrounded by trees. It contained flowers and other plantings native to Italy.

One

FRENCH LICK SPRINGS HOTEL
GOLD LEAF, STAINED GLASS, AND MARBLE

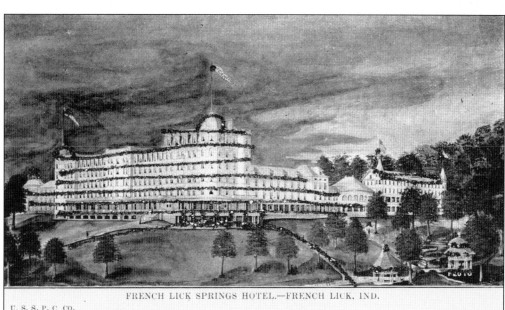

After the 1897 fire, the ruins of the French Lick Springs Hotel were purchased by a syndicate headed by Thomas Taggart, who was at that time the mayor of Indianapolis. Taggart, an Irish immigrant, started his career as manager of the Baltimore and Ohio Hotel at Garrett. After two years there he became manager of Union Station in Indianapolis. He was active in Democratic politics and was elected Marion County auditor. This postcard is postmarked August 23, 1906.

11

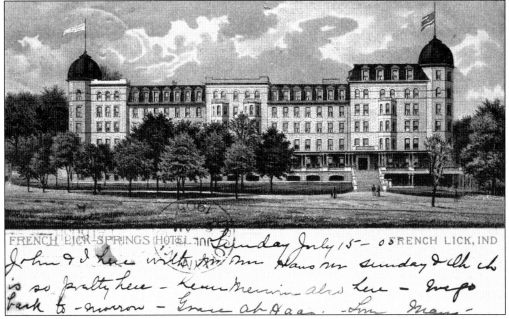

FRENCH LICK SPRINGS HOTEL *[handwritten postcard text]* FRENCH LICK, IND

Thomas Taggert's syndicate proceeded to rebuild a magnificent neoclassical edifice, which sparkled with stained glass, gold leaf details, and faux marble columns. Several additions were built until the hotel became the largest in the state of Indiana, with over 700 rooms. This postcard is dated July 13, 1905. It shows the profile of the front of the original building with its twin towers. The main entrance is on the right.

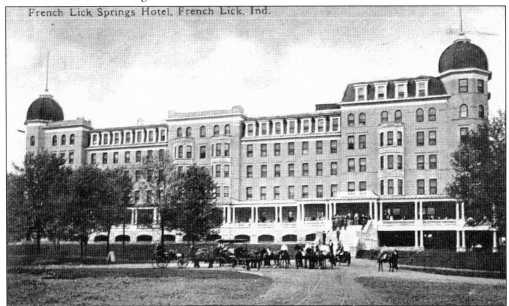

French Lick Springs Hotel, French Lick, Ind.

For many years the French Lick Springs Hotel was the site of many large conventions, including the National Governors' Conference in 1923 and 1932. Its many amenities include two 18-hole golf courses. There are several horses and buggies and people on saddle horses. Equestrian activities were a popular pastime. The open porch extends across the front of the building. There were rocking chairs and swings for those lazy days of summer.

12

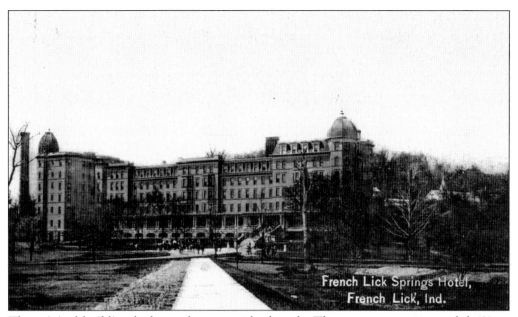

The original building had round towers at both ends. The towers were removed during a later remodeling.

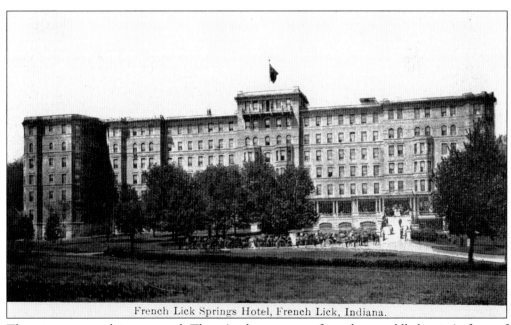

French Lick Springs Hotel, French Lick, Indiana.

These towers were later removed. There is a large group of people on saddle horses in front of the hotel. Over 50 miles of trails were marked for horse riding.

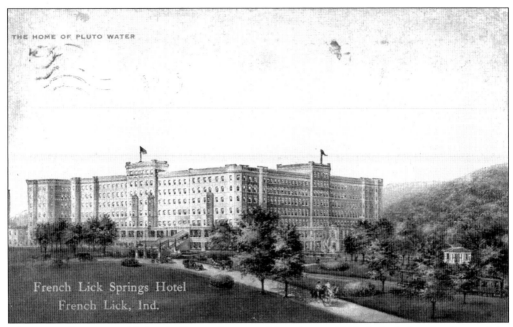

This view shows an addition built on the west side prior to 1915. It includes the slogan "the Home of Pluto Water."

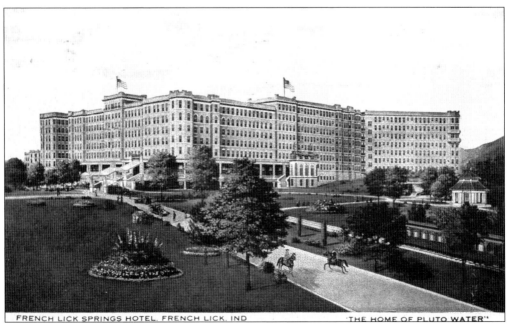

Another addition was built on an angle to add more rooms. Persons on horses are shown on the road. A private railroad car is in the right foreground. Wealthy patrons arrived in their private railroad cars.

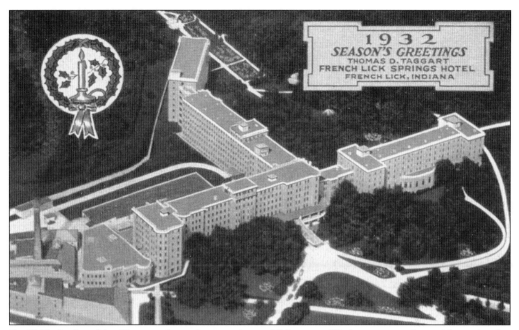

By 1932 the hotel had been enlarged many times. This was a Christmas greeting with a calendar on the back.

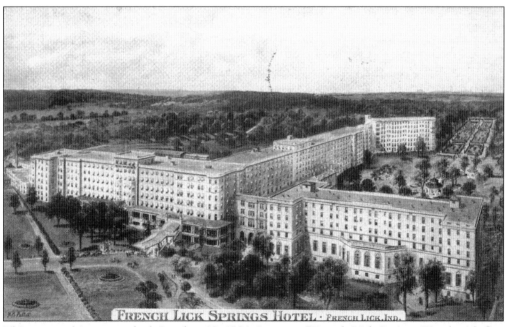

This postcard is postmarked October 13, 1934. It states, "French Lick Springs Hotel with five famous 18-hole golf courses, riding trails, and tennis courts is ideally located for conventions. French Lick is but a few miles from the center of population of the United States."

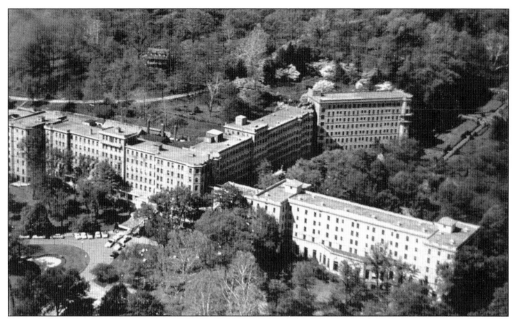

This postcard is postmarked April 7, 1960, after it had become the French Lick–Sheraton Hotel. The postcard states, "French Lick – Sheraton Hotel with two famous 18-hole golf courses, skeet and trap shooting, riding trails, outdoor and indoor swimming, and tennis courts is but a few miles from the center of population of the United States. Free Sheraton Hotels Reservations Via Teletype. Phone: LD9-Teletype: French Lick 471." The Sheraton Corporation acquired the hotel in 1954.

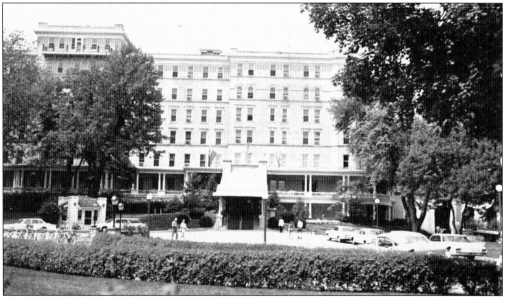

This postcard is dated August 14, 1966. It is addressed to Kalamazoo, Michigan. Its message states, "Sat. noon Hot. Hi! We came over here Thurs. & are really living it up! Didn't have one of their mineral baths yet but have made a tour of the place – very interesting. Jay is out playing golf this pm & then we go to a dinner & dance tonite . . . Has been very warm since arriving but rooms are cool."

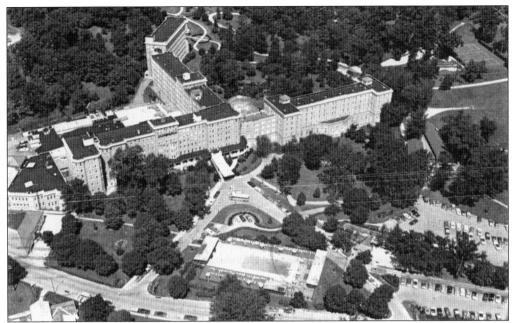

This postcard is dated May 31, 1984, and shows the outdoor pool in the foreground. The reverse side states, "French Lick Springs Golf and Tennis Resort . . . A world of fun is waiting on our 2600 wooded acres in Southern Indiana. Indoor/outdoor pools, golf (two 18-hole courses), indoor/outdoor tennis, riding stables, trap/skeet, bowling, bicycling, health club/spa, children's programs, dancing/entertainment. The perfect vacation place."

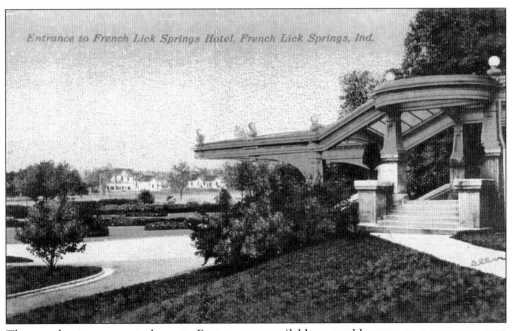

The grand entrance greeted guests. Porters were available to send luggage up a conveyor onto the porch. Bellboys took it to the room.

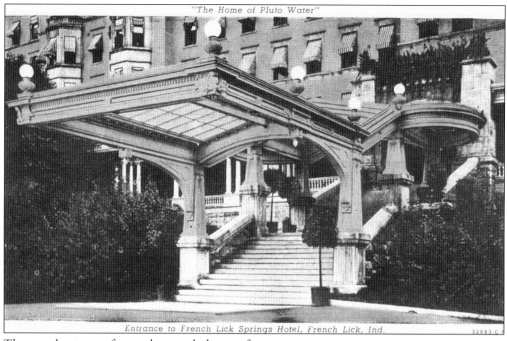

The grand entrance featured a grand glass roof.

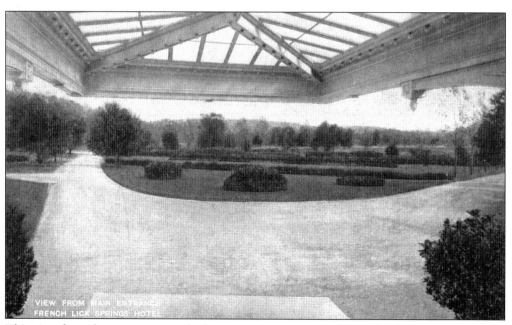

This view from the main entrance looks out on the entrance drives and well-kept gardens. The postcard was "Made by Pluto Press, French Lick, Indiana."

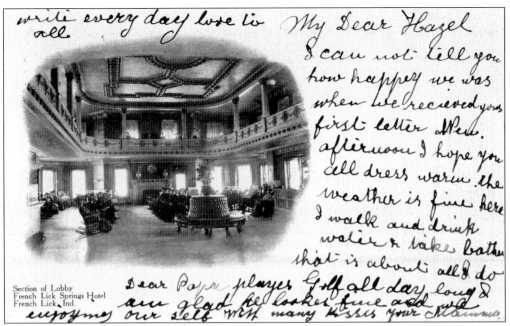

This postcard is postmarked October 12, 1906. This section of the lobby contained numerous rocking chairs. The message reads, in part, "I walk and drink water and take baths – that is all I do – Dear Papa plays golf all day long – I am glad he looks fine and are all enjoying ourselves."

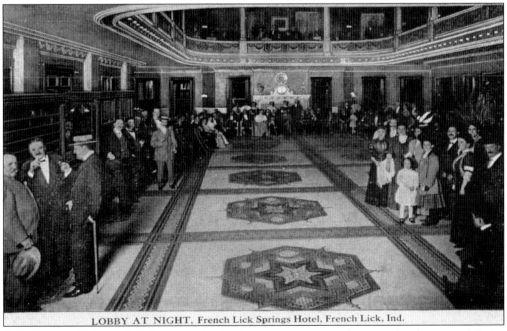

LOBBY AT NIGHT, French Lick Springs Hotel, French Lick, Ind.

Guests are well dressed and waiting in the lobby for dinner to be served. This postcard was "Published by Hotel Press, French Lick, Indiana."

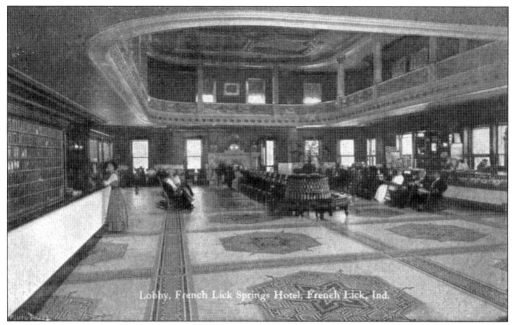

The terrazzo floor of the lobby is spectacular. Guests enjoyed the rocking chairs for leisurely interludes.

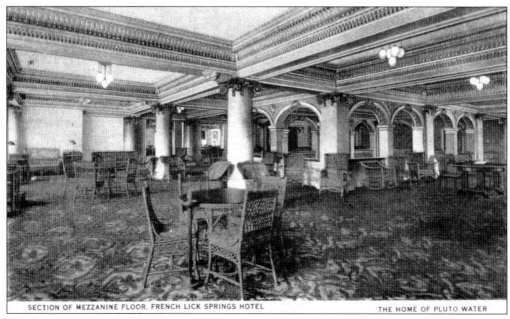

The mezzanine was located above the lobby and was outfitted with wicker furniture. The postcard is dated April 14, 1920. The message reads, "We are sitting right here to-night . . . Auntie moved in with me so I have a neat room."

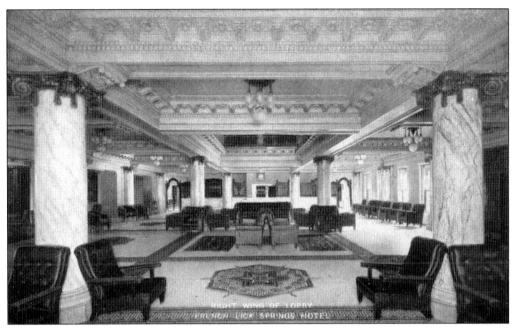

This right wing of the lobby featured leather-upholstered chairs. The mezzanine can be seen in the background.

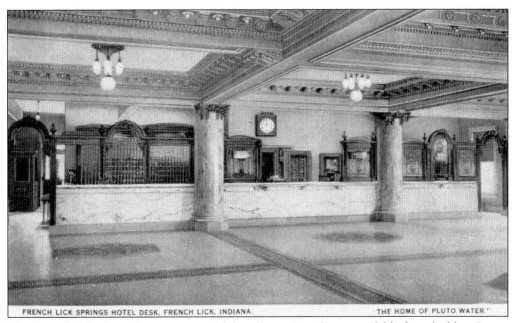

The front desk had a mahogany cage with brass bars. A vault was available for valuables. Guests were issued large brass keys for entry to their rooms.

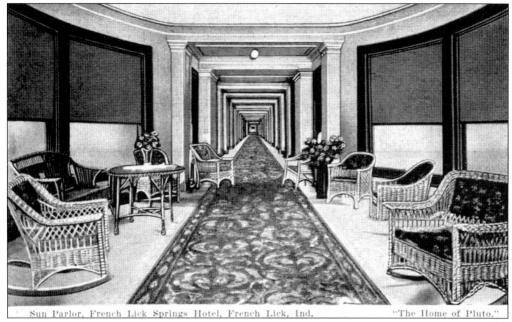

Wicker chairs and rockers provided a place to relax in the sun parlor. Decorative carpet runners were attractive. Fresh flowers were grown in the hotel's greenhouses.

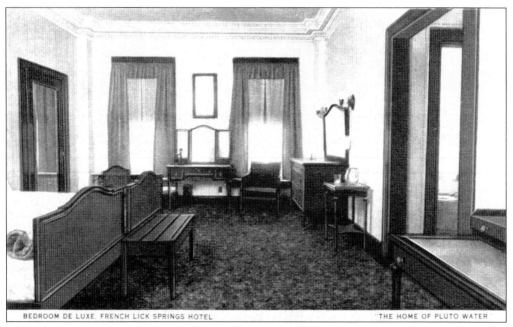

The deluxe room was rather sparse by present standards but was probably typical of a fine hotel in that era.

This postcard advertised the unique colored sandstone quarried near French Lick. The card states, "Seen a Rainbow Lately?? Dramatic! New! French Lick Sandstone proudly presents to you a range of colors that 'Rival the Rainbow'! This genuine Sandstone Building Veneer is quarried from the hills of Southern Indiana to 'Eye Condition' Your home. Build-in Color! Live in Beauty! With the Stone that's 'Hued by Nature'." The stone has a mottled orange, yellowish color.

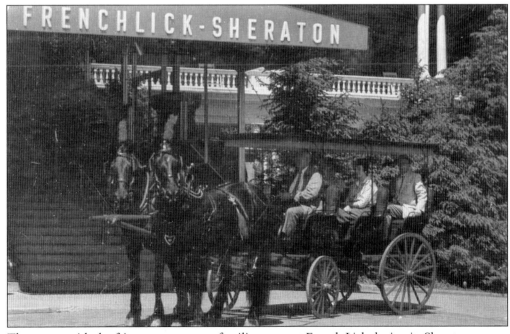

The surrey with the fringe on top was a familiar scene at French Lick during its Sheraton years.

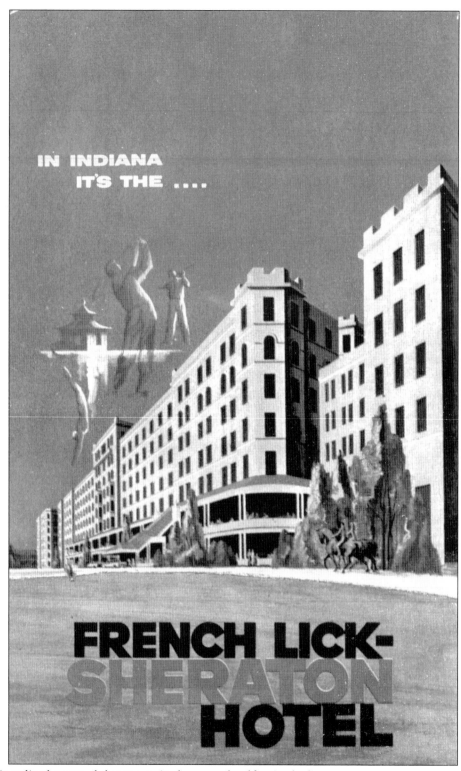

This stylized postcard shows a springhouse and golfers in shadow.

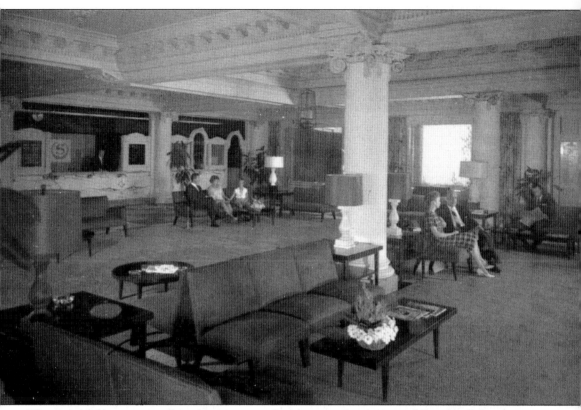

The grand lobby terrazzo floor is now covered with turquoise carpet and "modern" furniture. The back reads, "Telephone: Wellington 5-9381 – Teletype: French Lick 471. The most popular resort Hotel in the Midwest. Newly decorated and air-conditioned. Dining-rooms, Guest-rooms and Function Rooms. A complete program of social and athletic activities. Indoor and outdoor swimming. Two Golf Courses."

This foldout card was issued by the French Lick Springs Hotel. It shows an artist's rendering of the golf course adjacent to the hotel, a lovely place to take a walk, enjoy the fresh air,

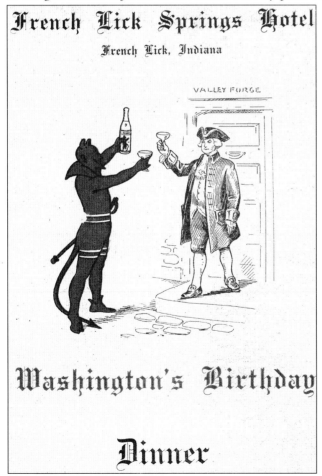

On the back of the foldout card was the menu for the French Lick Springs Hotel's Washington's birthday dinner. The menu and musical entertainment certainly look festive. Potatoes Martha must have been served to honor George Washington's beloved wife.

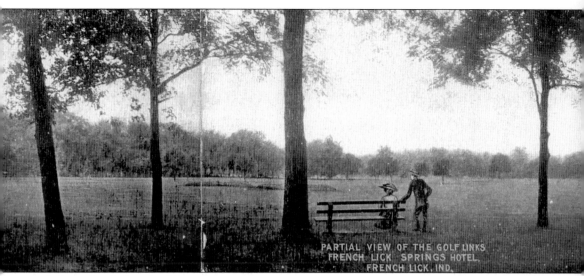

PARTIAL VIEW OF THE GOLF LINKS
FRENCH LICK SPRINGS HOTEL.
FRENCH LICK, IND.

and play a few holes of golf.

Anchovy Canape

Blue Points

Celery

Cream of Tomato Consomme, Printaniere Royal

Stuffed Mangoes Radishes Ripe Olives

Broiled Spanish Mackerel, Maitre d' Hotel

Sliced Cucumbers Potatoes, Martha

Oyster Patties

Roast Young Turkey, Cranberry Sauce

Lamb, Mint Sauce

Prime Ribs of Beef, au Jus

Mashed Potatoes Browned Sweet Potatoes

Braised Tenderloin Beef, Mushrooms

Peach Roll, Cream Sauce

Asparagus Brussel Sprouts Green Peas

National Punch

Lettuce and Tomatoes, Mayonnaise

Delaware Pudding, Rum Sauce

Meringue, Chantilly

Martha Washington Pie Gooseberry Pie

Valley Forge Ice Cream Assorted Cakes

American, Edam and Roquefort Cheese

Water Biscuits

Coffee

TUESDAY, February 22, 1910

Musical Program

FANTASIE: "America Forever" *Tobani*

MEDLEY: { "By the Light of the Silvery Moon" . *Edwards*

{ "Next to your Mother, who do you Love" *Snyder*

PATROL: "The Blue and the Gray" . . . *Dalbey*

MARCH: "Stars and Stripes Forever" . . . *Sousa*

Concert in Lobby, 8:15 p. m.

Solos by Members of Orchestra

REQUEST PROGRAM

from 9 to 10

Fred. C. Noble, Musical Director Dellinger Wood, Piano

Orville Eminger, Traps and Chimes Herman Coblitz, Flute

Guests were well fed and well entertained.

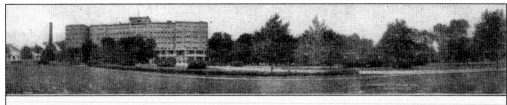

FRENCH LICK SPRINGS HOTEL
FRENCH LICK, INDIANA

Dinner

CREAM OF TOMATOE CONSOMME, CELESTINE

RADISHES SWEET PICKLES OLIVES

BAKED RED SNAPPER, CREOLE

SLICED CUCUMBERS POTATOES, PARISIENNE

BOILED LAMB'S TONGUE, PIQUANT SAUCE

ROAST RIBS OF BEEF, AU JUS ROAST SPRING CHICKEN, SAGE DRESSING

MASHED POTATOES BOILED POTATOES

BRAISED LEG OF VEAL, MUSHROOMS

SPAGHETTI, A LA ITALIENNE CHARLOTTE OF FRUIT, MERINGUE

LIMA BEANS BROWN SWEETS STEWED CORN

LETTUCE AND TOMATOES, FRENCH DRESSING

CORN BREAD AND BUTTERMILK

VIENNA APPLE PUDDING, FRUIT SAUCE

CREAM FRANCAISE, AU CHOCOLATE

PHILADELPHIA ICE CREAM VANILLA CREAM PIE

ASSORTED CAKE

WATERMELON

AMERICAN, EDAM AND BRIE CHEESE

WATER CRACKERS

COFFEE

THURSDAY, AUGUST 24, 1911

Guests using the waters should avoid The drinking water used in this hotel
uncooked fruits and raw vegetables is distilled

This menu is dated Thursday, August 24, 1911. This was a routine weeknight dinner.

This menu, dated Sunday, May 10, 1942, indicates that food must have been plentiful at French Lick even during World War II.

Dinner

Served from 12:30 to 2:30 P. M. 6:30 to 8:30 P. M.

APPETIZERS:	Tomato Juice Fresh Shrimp Cocktail	Kraut Juice	Fruit Juice Fruit Cocktail
SOUPS:	Cream of Fresh Tomatoes		Consomme with Rice
RELISHES:	Chilled Celery en Branch		Mixed Olives
FISH:	Broiled Filet of Lake Superior Trout, Lemon Butter		
ENTREES:	Roast Young Turkey, Sage Dressing, Cranberry Sauce Prime Rib of Roast Beef, Natural Gravy Breaded Tender Veal Cutlets a la Holstein Braised Calf Sweet Breads in Casserole, Green Peas French Pancakes with Currant Jelly Fresh Mushroom Omelette		

COLD BUFFET:	Sugar Cured Ham Hard Boiled Eggs Braunschweiger	Pickled Pigsfeet Chicken Thuringer	Oxtongue Potato Salad

VEGETABLES:	Fresh Green Peas Cauliflower in Cream Cream Whipped Potatoes		Fresh Leaf Spinach Parsley Butter Potatoes
SALADS:	Bibb Lettuce Salad, French Dressing		
CHEESE:	Port du Salut		American

DESSERTS:	Caramel Ice Cream Chocolate Sundae White Cake Macaroons Butter Cookies Apple Pie Cocoanut Custard Pie Charlotte Russe Chantilly Prune Plums Winesap Apples
DRINKS:	Sanka Tea Coffee Cocoa Milk Buttermilk
BREAD:	Whole Wheat Rye Bran Plain Rolls Graham Crackers

SUNDAY, MAY 10, 1942

Musical Program

KEN HARRIS, His Electronic Piano and His Tone Style Orchestra
Featuring the Voice of George Van

PART I

DRINK TO ME ONLY WITH THINE EYES _____ Old English Air

I'LL PRAY FOR YOU _____ Vocal by George Van

POR QUE _____ Tango

ANDANTINO _____ Adapted from "Moonlight and Roses"

MIAMI SHORES _____ Waltz

MY TWILIGHT DREAM _____ Adapted from Chopin's "Nocturne"

PART II

WALTZ IN Ab _____ by Brahms

JEALOUSY _____ Tango

ON THE STREET OF REGRET _____ Vocal by George Van

ARTISTS LIFE _____ Viennese Waltz by Johann Strauss

Medley Time:
 OUR LOVE
 STARDUST
 ON THE ISLE OF MAY
 I CRIED FOR YOU _____ Vocal by George Van
 STAIRWAY TO THE STARS

Extra Menus for mailing may be had from Head Waiter or at the Desk.

Guests were treated to a musical program after dinner featuring an "electronic piano."

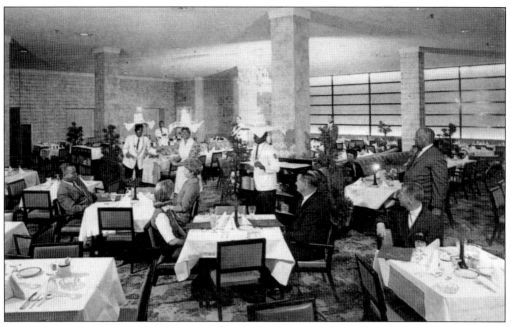

Fine dining continued under the Sheraton Hotel name. It is said that tomato juice was "invented" at the French Lick Springs Hotel in 1917, when the chef ran out of orange juice. He squeezed some tomatoes and served tomato juice, which became very popular.

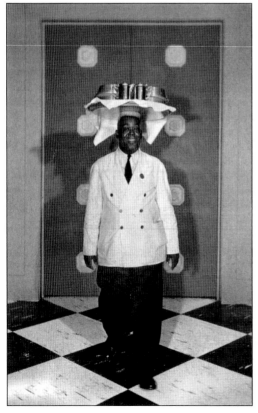

Dessert was brought into the dining room balanced on the heads of African American waiters vigorously dancing to "As the Saints Go Marching In" played by the house orchestra.

An advertisement for Meadow Gold Butter in *Life* magazine features a dancing waiter.

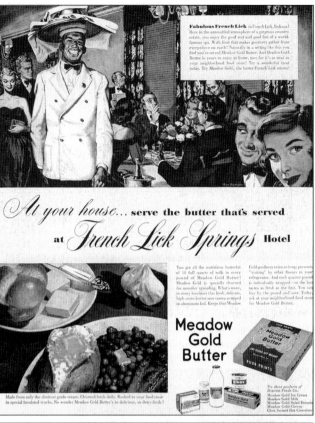

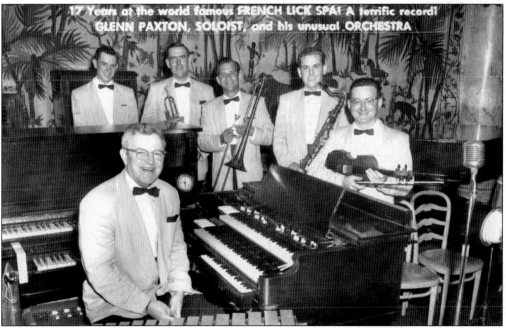

The house orchestra for many years, Glen Paxton and his unusual orchestra were longtime favorites for entertainment.

After drinking the sometimes foul-tasting mineral water, the fresh water would have been welcome.

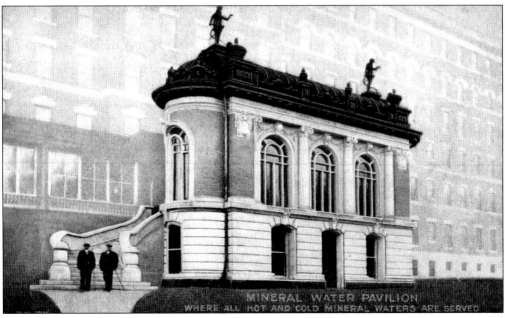

This elaborate edifice with bronze statutes of Pluto on its roof was attached to the hotel for the convenience of those wanting to "take the waters." Hot and cold mineral waters were served.

This postcard showing the Pluto Spring is dated November 17, 1916. The message "Is it coming off as soon as you expected? Times are pretty hard." probably referred to the recession of that period.

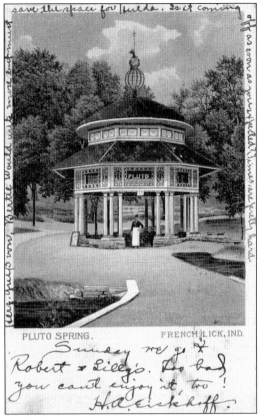

PLUTO SPRING.　　　　FRENCH LICK, IND.

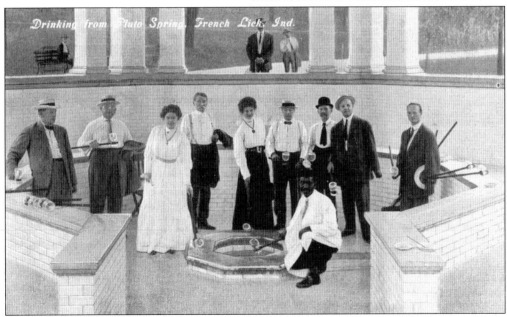

An African American waiter helps guests get a drink from the Pluto Spring. Glass goblets were held from a wooden stick and dipped into the water. Pluto water had high sulphur content, which smelled like rotten eggs.

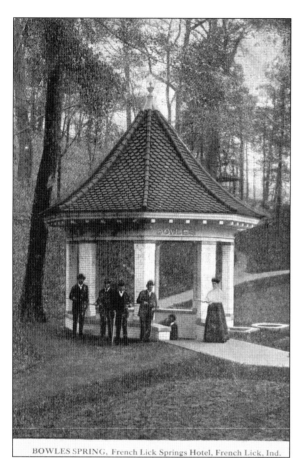

The Bowles Spring was named for Dr. William A. Bowles, who was the original owner of the hotel property. This postcard is dated March 14, 1909. The sender wrote, "Dear Elsie – The corn muffins here are not as good as yours."

BOWLES SPRING, French Lick Springs Hotel, French Lick, Ind.

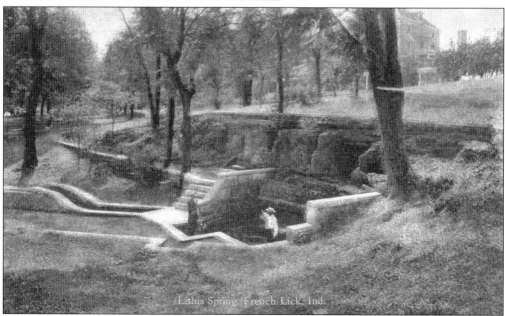

Lithia Spring, French Lick, Ind.

The Lithia Spring was located on the grounds a distance from the hotel.

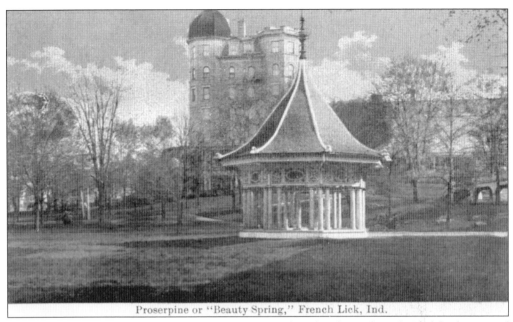

Proserpine or "Beauty Spring," French Lick, Ind.

This card shows Proserpine, or Beauty Spring in French Lick. The card is a divided-back postcard that was published in West Baden.

In Roman mythology, Proserpine had a love interest in Pluto.

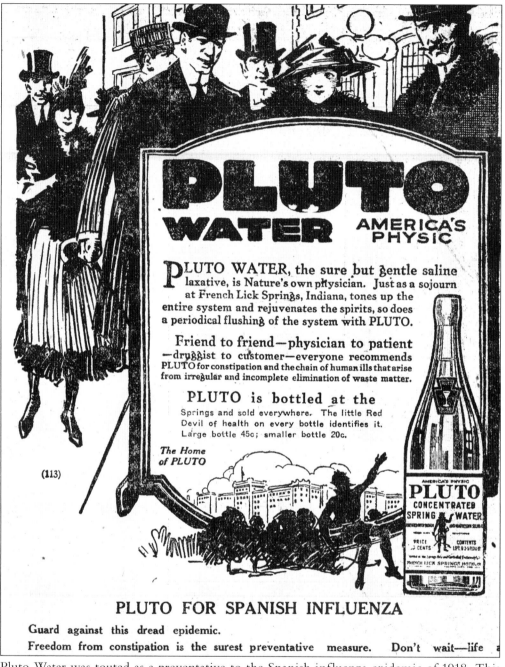

Pluto Water was touted as a preventative to the Spanish influenza epidemic of 1918. This advertisement referred to Pluto as "the Little Red Devil."

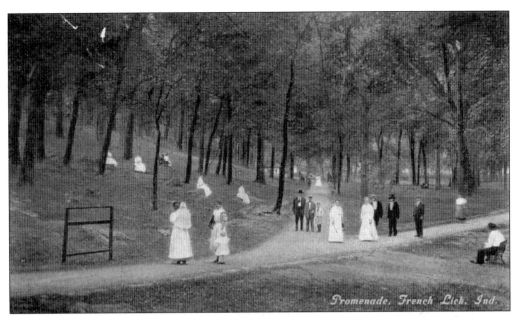

Guests were encouraged to take long walks for their health. The guests did not leave their rooms without rather formal clothes.

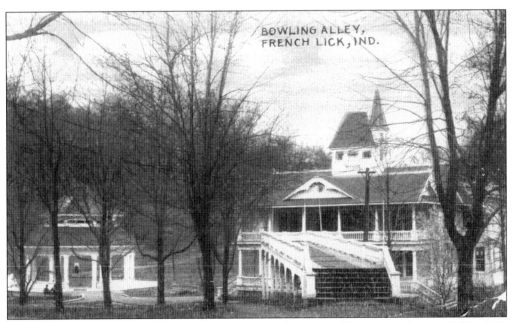

The bowling alley was one of the many attractions for guests. The postcard is dated March 8, 1909, and reads, "The place looks beautiful."

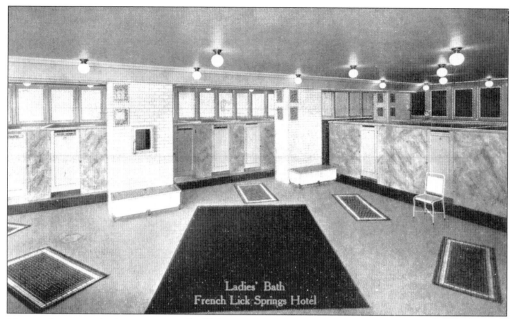

Men and women had separate spa facilities.

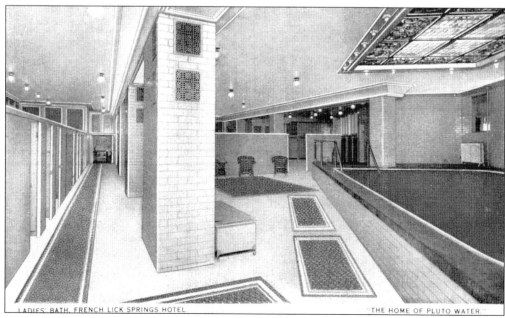

LADIES' BATH, FRENCH LICK SPRINGS HOTEL "THE HOME OF PLUTO WATER."

The ladies' swimming pool was elaborate with ceramic tile walls, terrazzo floors, and an art-glass skylight.

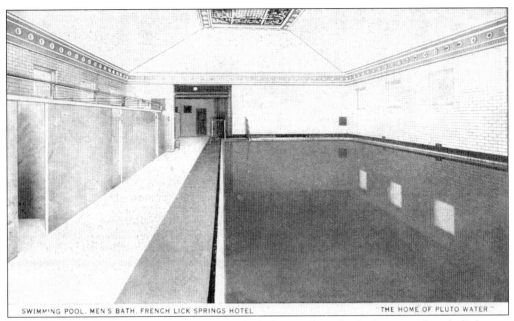

SWIMMING POOL, MEN'S BATH, FRENCH LICK SPRINGS HOTEL "THE HOME OF PLUTO WATER"

The men's swimming pool was larger than the ladies pool. It also had an art–glass skylight.

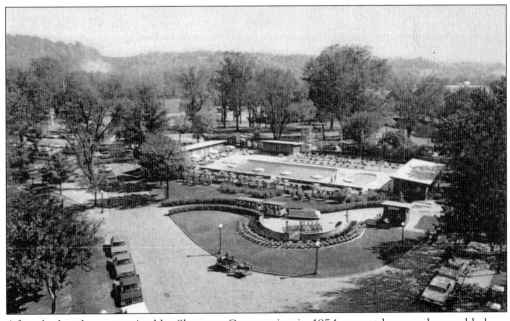

After the hotel was acquired by Sheraton Corporation in 1954, an outdoor pool was added.

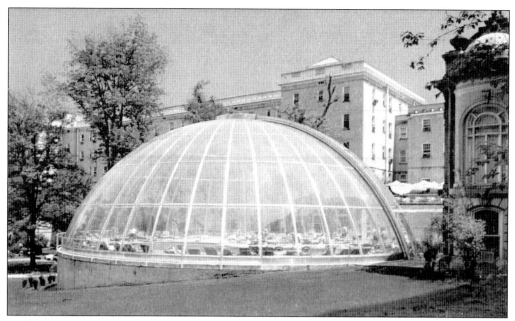

A dome provided an indoor/outdoor pool experience for guests at the French Lick–Sheraton Hotel.

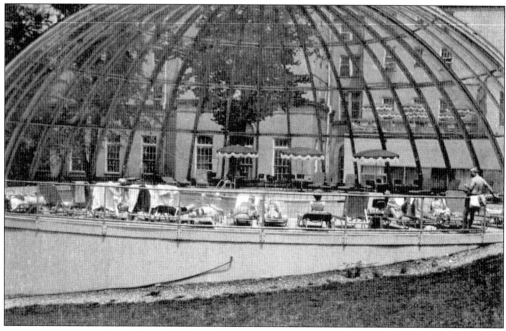

The reverse side describing the French Lick–Sheraton Hotel states, "Swim the year-round in either of two huge pools – indoor or out. And there's so much more to enjoy: Golf (two 18-hole courses), tennis, riding stables, trap/skeet, bowling, bicycling, health club/spa, dancing, entertainment, children's program."

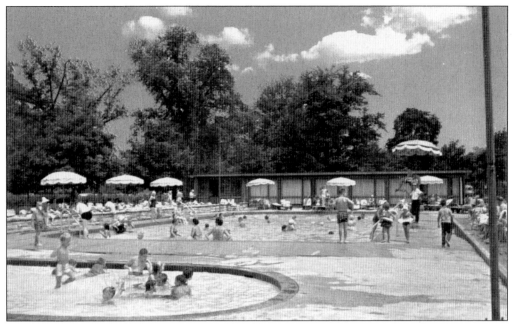

Families were encouraged to vacation at the French Lick–Sheraton Hotel. There were many activities for youth, and the swimming pool was popular among youngsters.

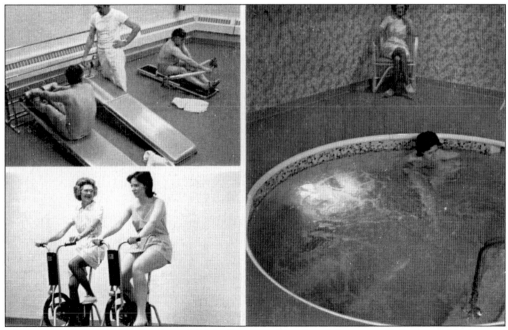

This postcard describing the French Lick–Sheraton Hotel and Country Club states, "Relax and slim down in our new Spa and Health Club. Separate facilities for ladies and gentlemen include sauna, steam, whirlpool, massage, exercise equipment, mineral baths, beauty salon. Also enjoy golf, indoor/outdoor tennis, swimming, riding, bowling."

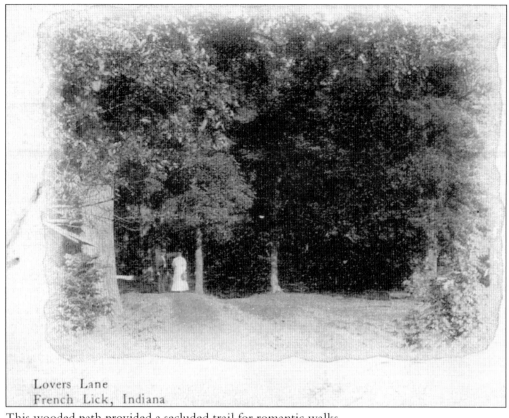

Lovers Lane
French Lick, Indiana

This wooded path provided a secluded trail for romantic walks.

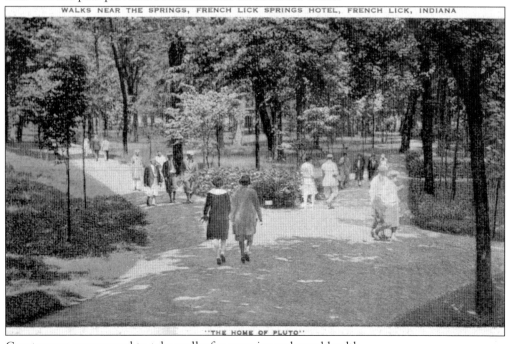

WALKS NEAR THE SPRINGS, FRENCH LICK SPRINGS HOTEL, FRENCH LICK, INDIANA

"THE HOME OF PLUTO"

Guests were encouraged to take walks for exercise and good health.

The Cumberland Hills provided some steep and interesting terrain.

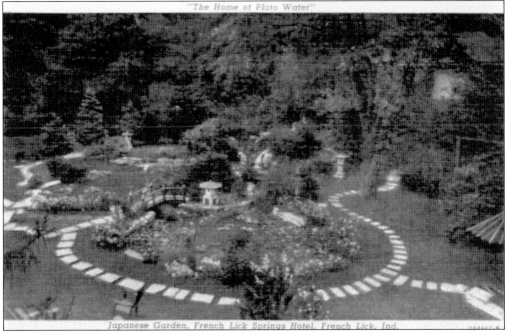

The grounds of the Japanese garden were beautifully landscaped. This postcard is dated October 2, 1942. The message reads, "Hope your union will send full quota of delegates to the State Convention and groups for 1 day, Wed. or Thurs." French Lick was a favorite place for conventions. An advertising pamphlet referred to a bowling alley and dice room in the middle of the Japanese garden.

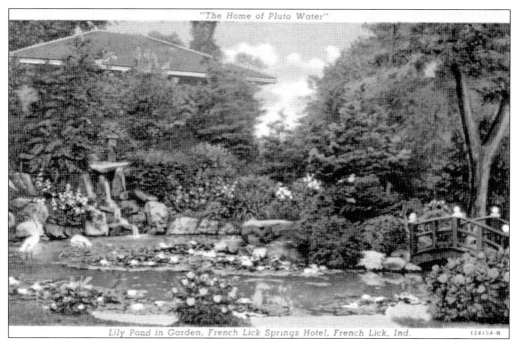

Lily Pond in Garden, French Lick Springs Hotel, French Lick, Ind. 124154-N

The lily pond was one of the most elaborate gardens. This postcard is postmarked July 3, 1945, and is addressed to "Pfc. Albert Jacobs at Hunter Field Georgia." The message was signed "Love, Ferne" and was addressed to "Dearest Al." She reports, "I wore my new bracelet last night and today. I've tanned deeply since coming to Ind."

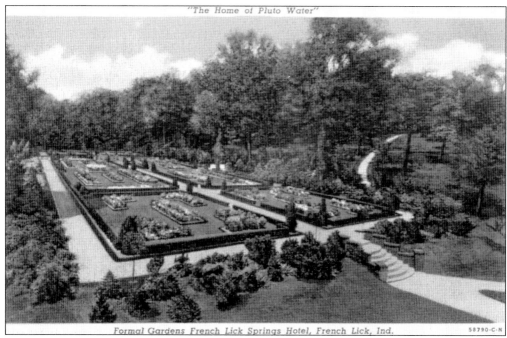

Formal Gardens French Lick Springs Hotel, French Lick, Ind. 58790-C-N

The formal gardens had spectacular flowers, hedges, bushes, and manicured lawns.

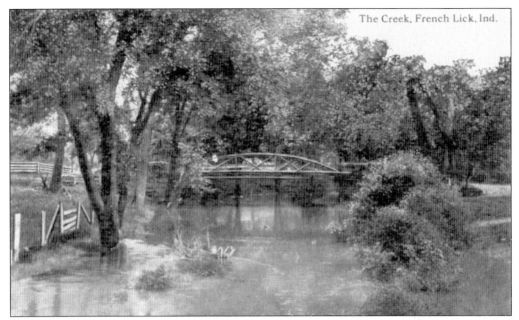

The Creek, French Lick, Ind.

The creek is a tributary of Lost River, which flows belowground in some places and contains a species of blind fish. This postcard is addressed to "Miss Erma Brubeck" and the message reads, "Hello Girlie – How might you be? I'm fine and dandy. . . Aunt Rachie Holland got married. What do you think of that? Ha! Ha! It's time we were getting busy isn't it – Oh I forgot you and I had made a resolution to live to be a homely old maid – Ha!"

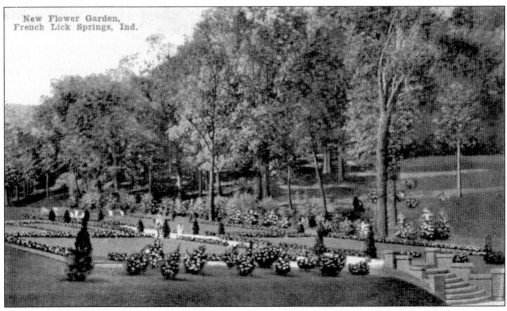

New Flower Garden, French Lick Springs, Ind.

The new flower garden provided more space for pleasant walks. The Taggarts strived to make the hotel grounds a horticultural showplace.

GREENHOUSES, French Lick Springs Hotel, French Lick, Ind.

Fresh flowers were grown in the greenhouses year round for the floral arrangements placed throughout the hotel. This postcard is postmarked September 17, 1907. The message states, "I send you greetings from French Lick. Good crowd here drinking and bathing. Wish you were here."

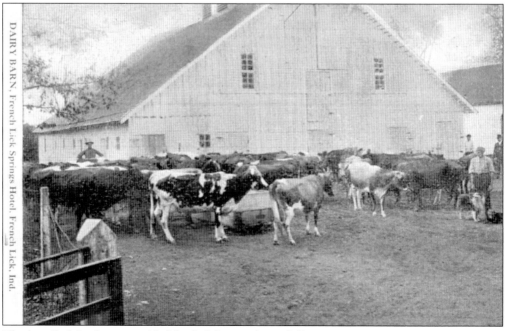

DAIRY BARN, French Lick Springs Hotel, French Lick, Ind.

The hotel's dairy barn provided fresh dairy products daily.

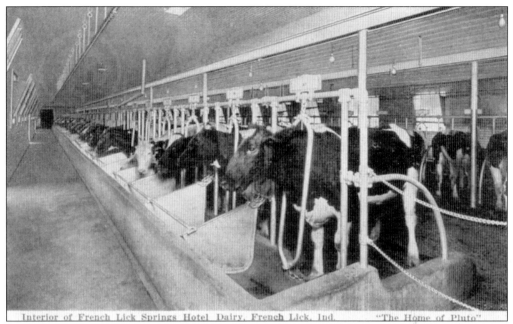

Interior of French Lick Springs Hotel Dairy, French Lick, Ind. "The Home of Pluto"

A large herd of Holstein cows produced ample milk for the hotel dairy to be served in the hotel's dining rooms.

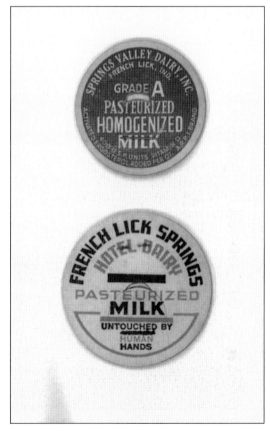

The hotel had its own dairy and also sold milk retail in the local area. This milk bottle cap indicates that the contents were "Untouched by Human Hands."

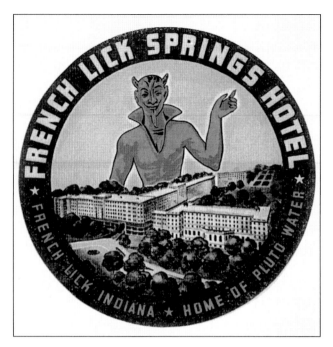

Guests were given stickers to affix to their luggage. It was common for travelers to get a sticker at each destination. They placed the sticker on their luggage to show where they had been.

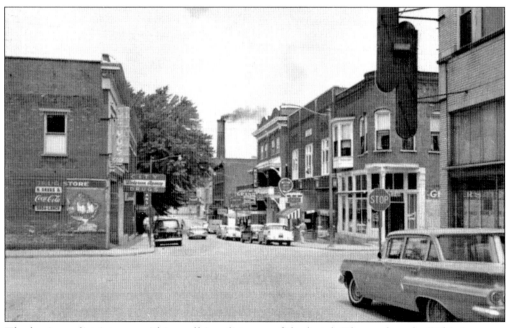

The business district was within walking distance of the hotel. The card reads, "This is a very busy street which finds many people from out of town, as well as local people, shopping in the fine business establishments."

Two

West Baden
Springs Hotel
The Eighth Wonder of the World

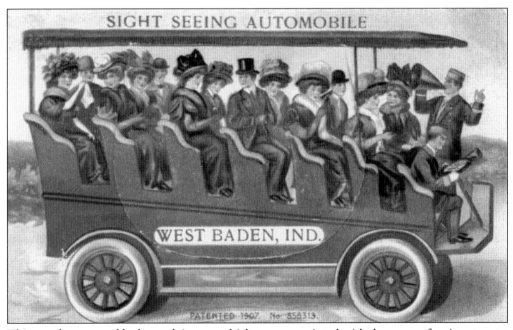

This novelty postcard had a stock image, which was overprinted with the name of various towns. It is postmarked October 23, 1908. The middle of the vehicle can be lifted up to reveal a cascade of small pictures of West Baden.

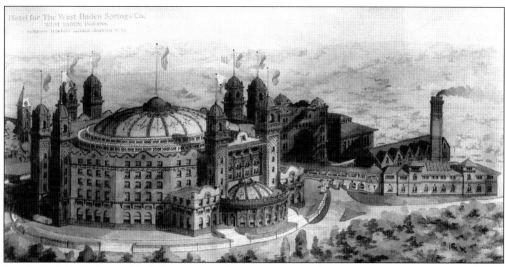

Lee Wiley Sinclair acquired the West Baden Springs Hotel in 1887. Sinclair was a successful mill owner from Salem who is credited with the creation of denim blue jeans. After he acquired the hotel, he made improvements including an opera house and double-decker bicycle track in 1893 and a casino in 1895. This architect's rendering by Harrison Albright, an architect from Charleston, West Virginia, was approved by Sinclair. The actual building differs only slightly from the rendering.

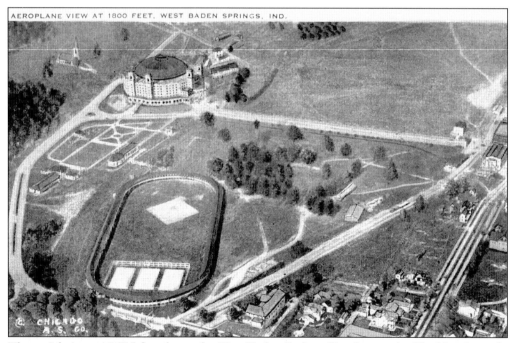

The aerial view at 1,800 feet shows the West Baden Springs Hotel grounds. The bicycle track, with tennis courts and baseball field in the center, is in the lower left corner. The gardens and spring houses are below the hotel. The Lady of Lourdes Cathedral is to the left of the hotel. The natatorium and other buildings are to the upper right from the hotel. The Monon Side track is on a diagonal line from the upper right to the lower left corner.

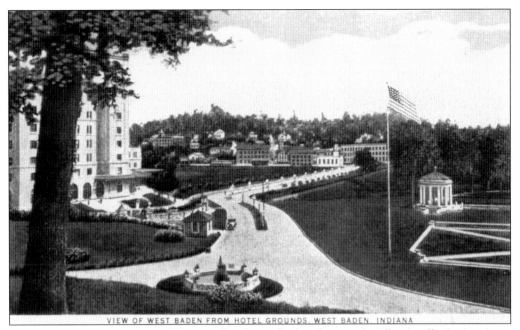

VIEW OF WEST BADEN FROM HOTEL GROUNDS. WEST BADEN. INDIANA

This postcard gives a view of West Baden from the hotel grounds. The Apollo Spring is on the right.

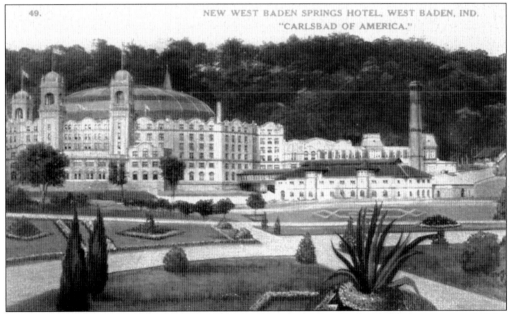

In this view of the new West Baden Springs Hotel, the spectacular edifice is surrounded by manicured gardens—an awesome sight. The reverse reads "New West Baden Springs Hotel, West Baden, Ind. – This noted watering place is located in Southern Indiana, surrounded by a cluster of hills, making it an ideal resting place."

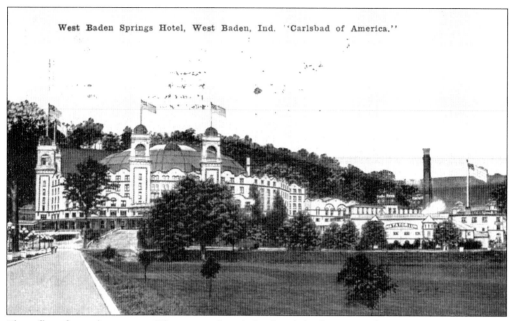

Flags flew from the towers. The natatorium is in the right foreground.

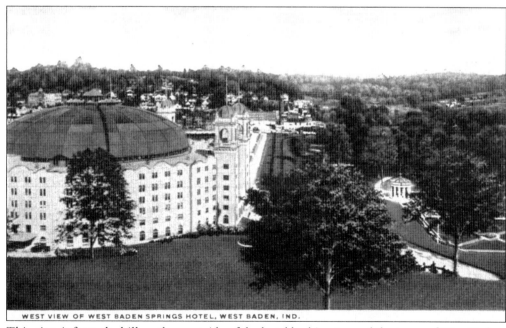

This view is from the hill on the west side of the hotel looking toward the town of West Baden. This postcard is dated August 28, 1928. The message in a child's handwriting reports "Mama didn't like the water."

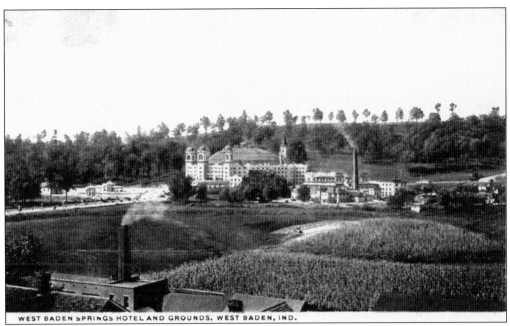

WEST BADEN SPRINGS HOTEL AND GROUNDS. WEST BADEN, IND.

This view shows the hills to the west and the sprawling grounds. While the West Baden Springs Hotel was the crown jewel of his holdings, Ed Ballard also owned the Grand Hotel on Mackinac Island, Michigan.

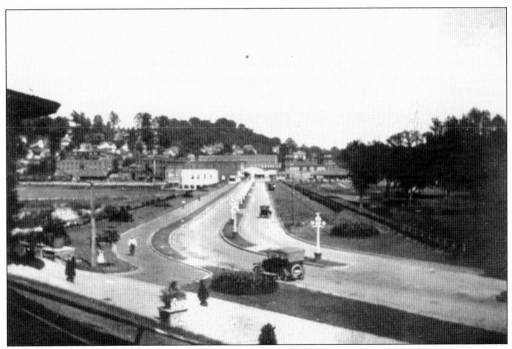

A boulevard drive paved with brick and lit with gaslights provided a formal entrance to the hotel grounds. As the automobile came into wider usage, Lee Sinclair built a large garage to house guests' cars and also provided quarters for their chauffeurs. Sinclair drove a big, red 1908 Buick touring car around the area.

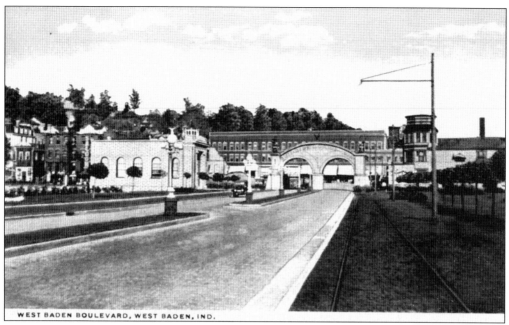

WEST BADEN BOULEVARD, WEST BADEN, IND.

The Spring Valley State Bank's limestone building is on the left on West Baden Boulevard. Originally Lee Sinclair had a bank in the hotel lobby. His daughter Lillian did not like the local "common folk" traipsing through the lobby, so built the bank building on the edge of the grounds. The Brown Hotel is in the center, and Fair Store is on the right.

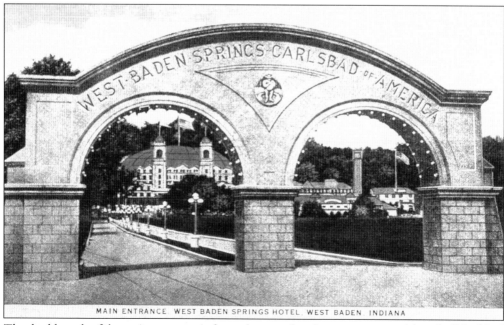

MAIN ENTRANCE, WEST BADEN SPRINGS HOTEL, WEST BADEN, INDIANA

The double arch of the main entrance informed guests that they were approaching the "Carlsbad of America." The "Sprudel Elf" is in the center. The slogan Carlsbad of America refers to the noted spa at Karlovy Vary, Czechoslovakia, which translates to Carlsbad in German. *Sprudel* is the German word for "spring."

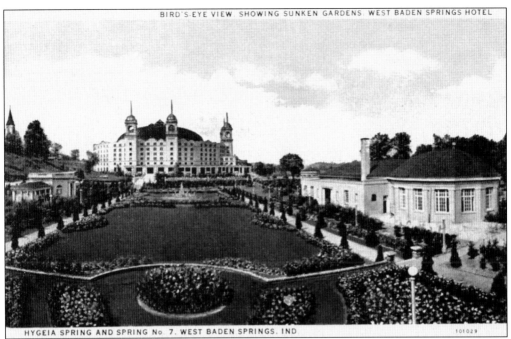

HYGEIA SPRING AND SPRING No. 7. WEST BADEN SPRINGS. IND

This bird's-eye view shows the sunken garden, the hotel, the Hygeia Spring and Spring No. 7. There were actually only four springs, but the numbering system made it appear as if there were seven. The hotel published a daily newspaper for guests.

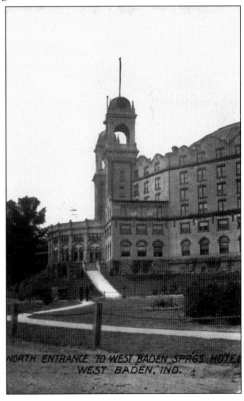

NORTH ENTRANCE TO WEST BADEN SPRGS HOTEL
WEST BADEN, IND.

This postcard view of the north entrance is dated June 9, 1911. The message reads in part "Rich is resting fairly well."

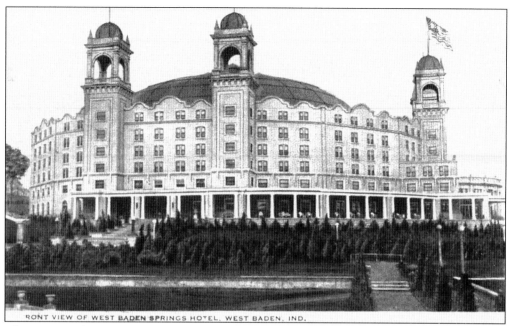

RONT VIEW OF WEST BADEN SPRINGS HOTEL, WEST BADEN, IND.

The open porch was added in the 1917 renovation. This postcard is postmarked August 13, 1923. The message reads, "Just picture your Aunt Doe Doe stepping out at this place. Too beautiful for words. Wish you could see it all with us. It takes all day to go thru the place and its grounds. Time is passing too fast to suit me. There is to be a big dance here tonight. Will write later. Love to all. Aunt Zoe."

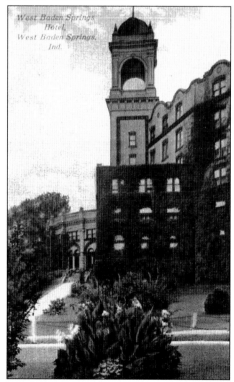

Ivy-covered walls provided a sense of permanence. The room rates were $14 per night on the American plan, which included all meals. All rooms had "private lavatory and running water." The room rate included free golf, tennis, bowling, billiards, swimming, and a "Bridge Tea Party for the ladies at our fashionable club."

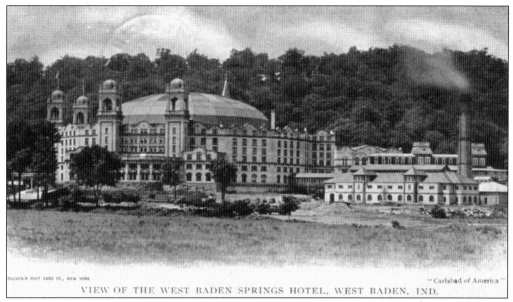

SOUVENIR POST CARD CO., NEW YORK. "Carlsbad of America"

VIEW OF THE WEST BADEN SPRINGS HOTEL, WEST BADEN, IND.

The original West Baden Springs Hotel burned to the ground on June 14, 1901. Guests were warned of the fire when the watchman fired his gun in each hallway. Fortunately all guests escaped the blaze. Lee Sinclair rebuilt a few years later. This early postcard view of the new hotel is dated May 9, 1905. The grounds have not yet been landscaped.

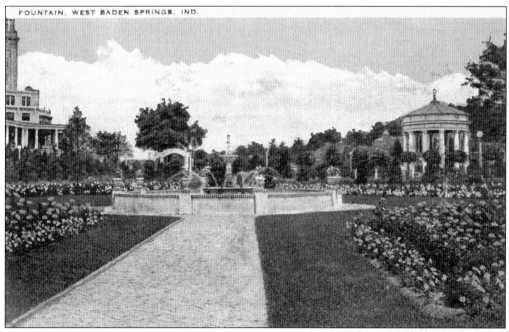

FOUNTAIN. WEST BADEN SPRINGS, IND.

The fountain is the centerpiece of the garden area of the West Baden Springs Hotel. The hotel can be seen in the upper right side.

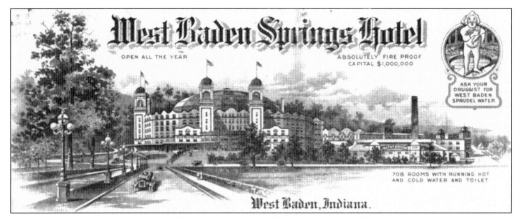

This image is printed on an envelope provided with stationery for the use of guests. It notes that the hotel is "Open all year," is "Absolutely Fire Proof, has Capital $1,000,000," and "708 Rooms with running hot and cold water and toilet." Sprudel Water was available on the grounds and was also bottled and sold in drugstores nationally.

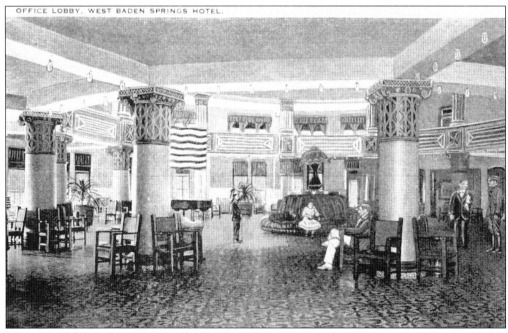

The office lobby of the West Baden Springs Hotel was spacious and ornate. The mezzanine level was available for guests.

The Lady of Lourdes Cathedral was built on the grounds near the hotel for the convenience of Catholic guests. The cathedral was razed in 1934 because of structural problems.

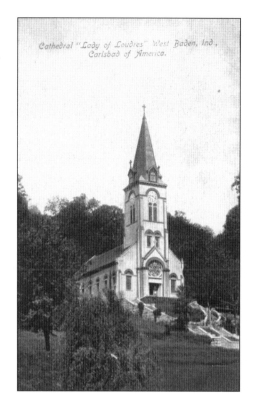

This stock card depicts a couple "spooning."

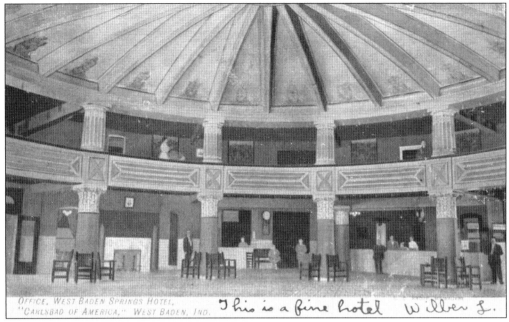

OFFICE, WEST BADEN SPRINGS HOTEL.
"CARLSBAD OF AMERICA," WEST BADEN, IND. *This is a fine hotel Wilber L.*

This view shows the lobby and front desk. There was a vault for valuables. The mezzanine was lined with writing desks for guests to write messages home. There was a bank in the lobby for the convenience of guests. During the Ballard years, Logan and Bryan, a stockbroker, maintained an office at the hotel.

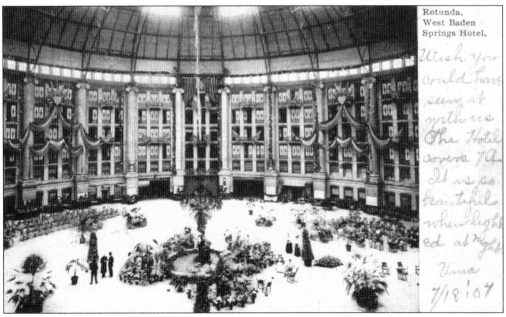

Rotunda, West Baden Springs Hotel.

Wish you could have seen it with us The Hotel covers 7A. It is so beautiful when lighted at night. Uma 7/18/04

Dated July 18, 1904, this early view shows the interior of the rotunda. The message reads, "Wish you could have seen it with us. The Hotel covers 7A. It is so beautiful when lighted at night."

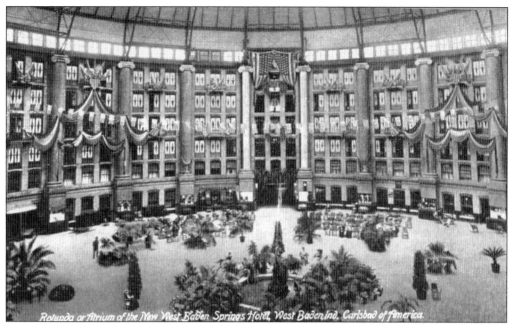

Rotunda or Atrium of the New West Baden Springs Hotel, West Baden Ind. Carlsbad of America.

Postmarked December 17, 1909, this view shows the palms, flowers, and fountain along with the red, white, and blue bunting draped from the columns in the rotunda of the atrium. The groups of chairs were probably for concerts. There were many shops around the outside perimeter of the atrium, including a barbershop, beauty parlor, cigar shop, and oriental shop.

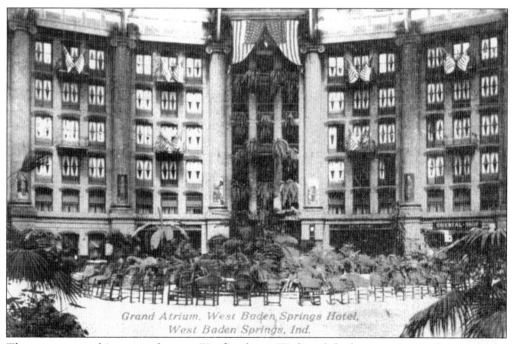

Grand Atrium, West Baden Springs Hotel,
West Baden Springs, Ind.

The message on this postcard states, "Its fine here. We heard the best music tonight over at the place on [the] picture." The configuration of the atrium was frequently changed. The atrium could accommodate up to 1,500 people for a sit-down dinner.

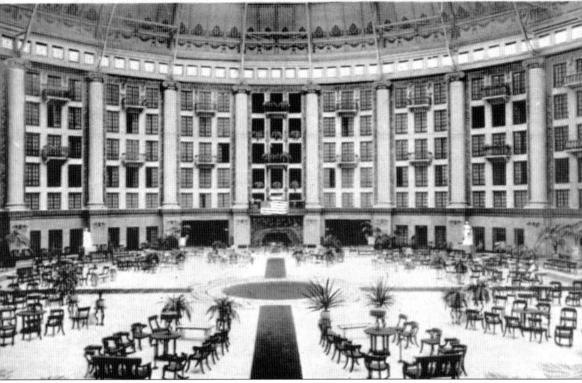

At 65, Col. Lee Sinclair might have retired and enjoyed his wealth, but he was urged by his daughter, Lillian, to rebuild a grand hotel. Sinclair had a vision of a freestanding dome comparable to St. Peters Basilica in Rome with the hotel rooms surrounding a courtyard under the dome. Many architects refused a commission, thinking that the proposed dome was impractical, if not impossible. Finally a young architect from West Virginia, Harrison Albright, accepted the commission and designed what was to be called "the Eighth Wonder of the World." Caldwell and Drake Construction Company of nearby Columbus agreed to complete the edifice for $414,000 within 200 days, with a penalty of $100 per day if the project ran over. The huge fireplace in the background is surrounded by tile from the Rookwood Pottery Company.

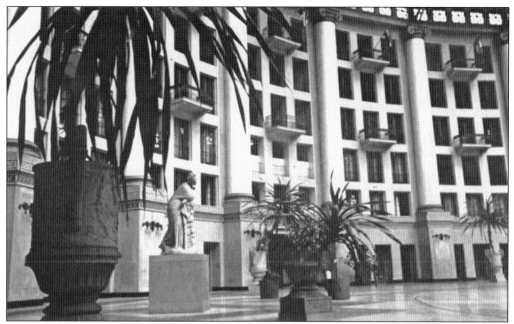

The caption on the verso of this postcard states: "The Great Atrium at Northwood Institute in West Baden, Indiana is a magnificent, domed courtyard 208 feet across and 150 feet high. Now under restoration by the college, this view shows the Atrium as it was in the early part of the century. The college is open to visitors."

Hundreds of railroad cars brought the necessary materials for the original construction. Over 500 men were hired. Bricklayers were paid 50¢ per hour, and general labor was paid $1 per day. There was over 10,000 square feet of glass in the dome, which was 200 feet in diameter and had an interior height of 100 feet. There were 708 rooms, all featuring private baths. When the hotel was opened, on September 15, 1902, Harrison Albright stood on top of the massive dome while interior supports were removed, proving his confidence in his design. The floor, columns, and Rookwood fireplace of the atrium are pictured after restoration.

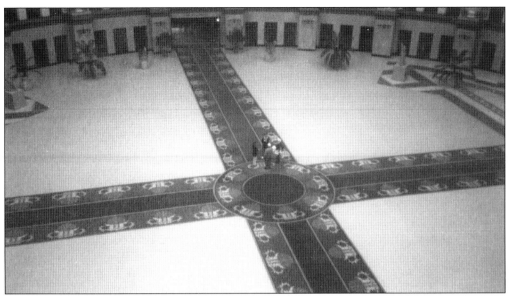

In later days, the atrium was used for car shows staged by students at the Northwood Institute. This view shows the atrium after restoration, as seen from a sixth-floor balcony.

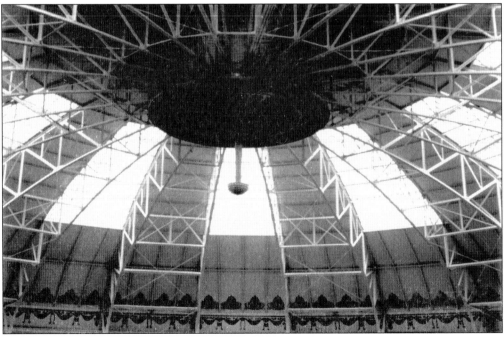

This view shows the dome as it appeared after restoration. The hotel was a huge success and attracted national publicity and thousands of guests. Lee Sinclair had bested Thomas Taggart in the opulence of his hotel.

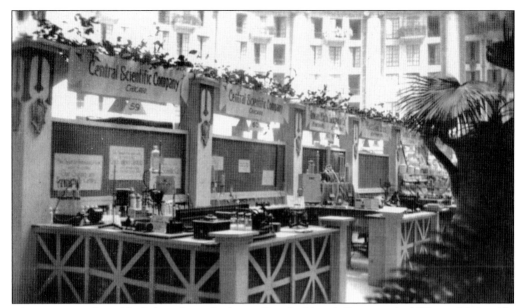

The atrium made an ideal place for trade shows. Booths 59 and 60 are marked "Central Scientific Company – Chicago." There was 40,000 square feet of exhibit space. A luxurious office was furnished for convention or trade show staff.

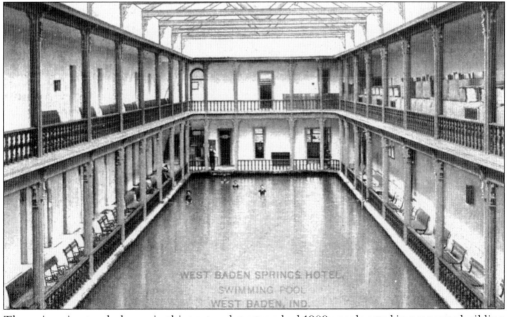

The swimming pool, shown in this postcard, postmarked 1909, was located in a separate building called the natatorium. The message reports, "We took a car ride yesterday . . . and saw the greatest hotel I ever saw."

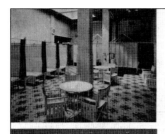

Lee Wiley Sinclair died on September 16, 1916. His daughter Lillian inherited the hotel and managed it with her husband Charles Rexford. During her tenure, Lillian dubbed the hotel "the Temple of Health and Happiness." To make major improvements, they borrowed $500,000 from Ed Ballard, who owned the Brown Casino. Income declined, and Lillian leased the hotel to the United States government for Army Hospital No. 35. While she was estranged from Charles Rexford, she met and fell in love with a soldier who was a patient at the army hospital. She later married him after divorcing Charles Rexford. Lillian sold the hotel to Ballard in 1922 in exchange for $500,000 plus forgiving the debt of $500,000.

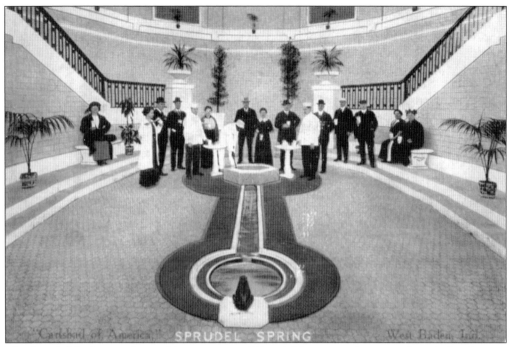

The Sprudel Spring was located in a separate edifice. African American attendants assisted guests in getting a cup of the allegedly curative water from the well.

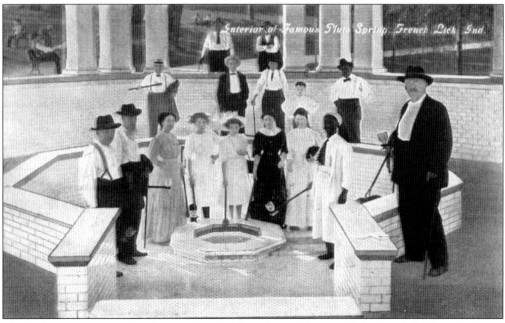

The African American female attendant holds a glass goblet on a forked stick used to dip water out of the spring.

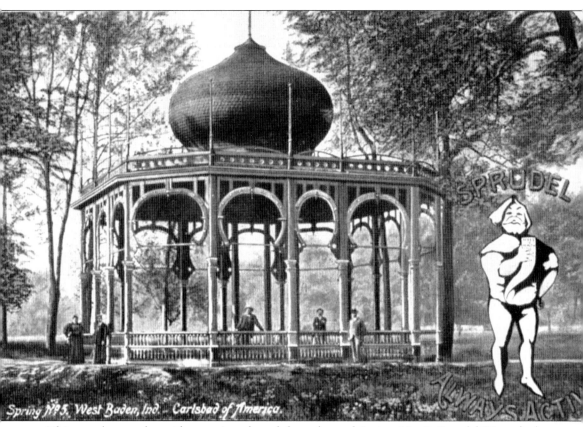

This wooden gazebo with an onion-shaped dome housed Spring No. 5. Sprudel Water had a diuretic effect, which "flushed out the body."

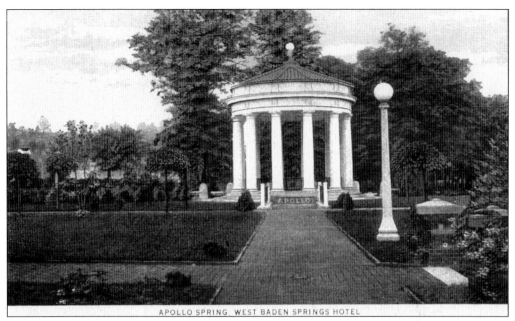

APOLLO SPRING, WEST BADEN SPRINGS HOTEL

This wonderful structure housing the Apollo Spring was located within the gardens surrounding the hotel.

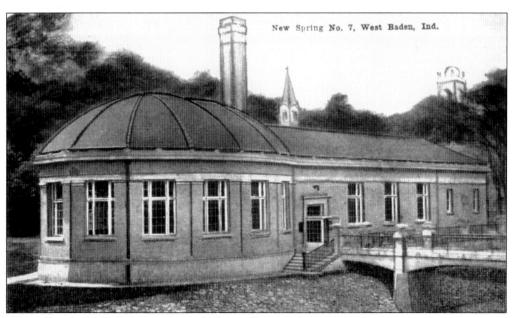

New Spring No. 7, West Baden, Ind.

This yellow brick building with a red tile roof housed Spring No. 7.

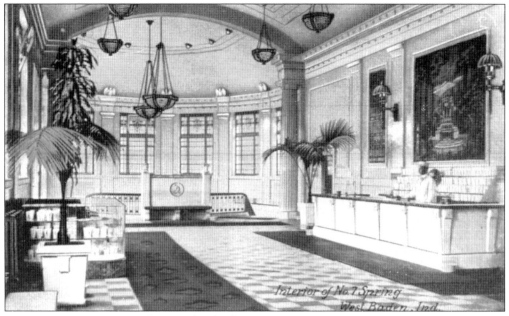

At Spring No. 7 guests could get a drink of mineral water at the counter on the right or could go down the stairway to dip the water from the spring themselves.

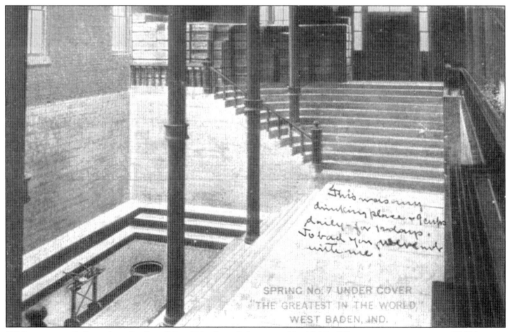

This postcard showing Spring No. 7 is dated August 19, 1909. The message reports, "This was my drinking place – 9 cups daily for 12 days. To[o] bad you were not with me!"

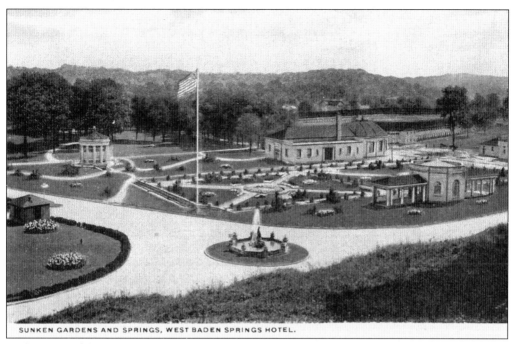

SUNKEN GARDENS AND SPRINGS, WEST BADEN SPRINGS HOTEL.

In this view of the sunken garden, the Apollo Spring is on the left, Spring No. 7 is in the middle, and the Hygeia Spring is on the right. The Cumberland Hills are in the background.

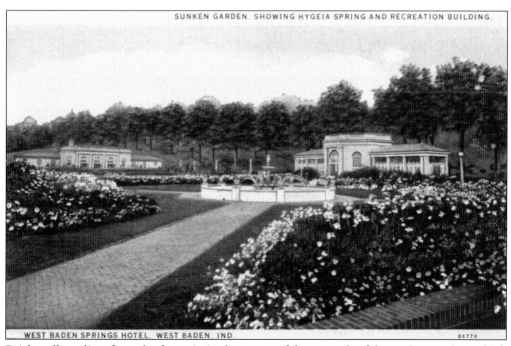

SUNKEN GARDEN, SHOWING HYGEIA SPRING AND RECREATION BUILDING.

WEST BADEN SPRINGS HOTEL, WEST BADEN, IND.

Brick walks radiate from the fountain in the center of the grounds of the sunken garden, which featured the Hygeia Spring.

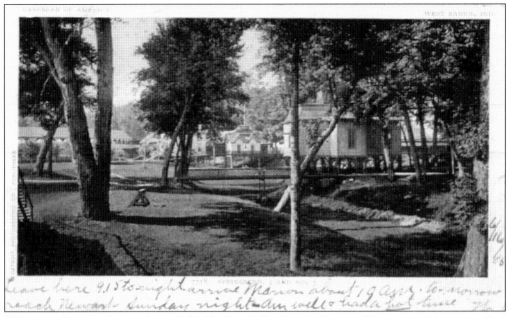

This view shows earlier versions of the No. 3 and No. 7 springhouses. The postcard is postmarked June 12, 1905. The message states, "Leave here 9:15 tonight – arrive Marion about 9AM to-morrow – reach Newark Sunday night – Am well & had a hot time." Most guests arrived and departed by train.

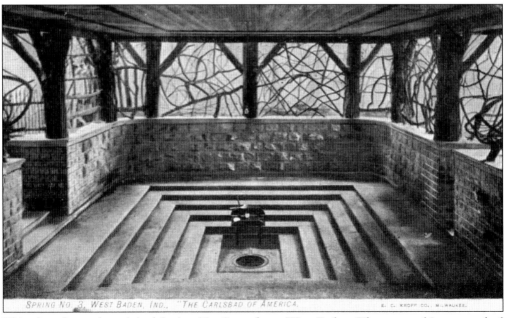

This view shows the original Spring No. 3 gazebo at West Baden. The postcard is postmarked August 30, 1907.

YOU AUTO BE WITH ME

824

West Baden, Sp'gs.

Love & best wishes. from Elizabeth Kla[...]

This novelty postcard is postmarked October 10, 1905. Owner Ed Ballard owned several other hotels in West Baden as well as casinos offering roulette, baccarat, bird cage, and slot machines. Ballard did not permit locals to gamble in the casino, fearing that they might have losses and cause trouble with local law enforcement officers. Ballard also owned casinos in Hot Springs, Arkansas; Miami, Florida; Saratoga Springs, New York; and Havana, Cuba. Ballard was stabbed to death in his casino at Hot Springs by Silver Bob Alexander on November 6, 1931. His body was returned to the West Baden Springs Hotel, where it laid in state until interment.

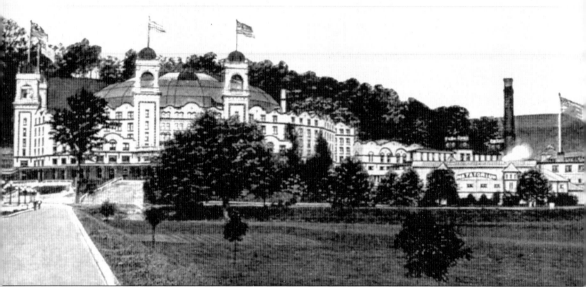

During World War I, the United States government rented the hotel for a military hospital. While he owned the hotel, Ed Ballard established a hospital on the second floor for the use of local residents. On Christmas Day 1918, the Hagenbeck-Wallace Circus did a performance for the army hospital patients in the atrium, complete with lions jumping over a blazing fence and five elephants, which performed "very intelligently."

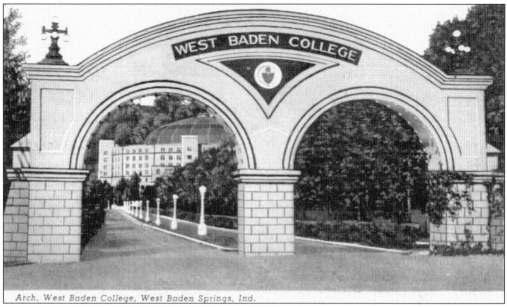

Arch, West Baden College, West Baden Springs, Ind.

The stock market crash in 1929 ended the heyday of opulent spas. The guests left in droves and did not come back. In 1930–1931, occupancy averaged only 10–15 guests per night in the 708-room hotel. Although the West Baden Springs Hotel prospered under the ownership of Ed Ballard, business suffered badly as a result of the market and the hotel was closed on July 1, 1932. Failing to find a buyer, Ballard donated the hotel to the Jesuits who established the West Baden College. The Jesuits (Society of Jesus) occupied the premises until 1964.

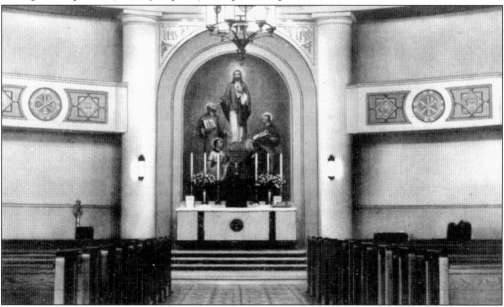

The Jesuits modified the original hotel lobby into their chapel. Many of the original ornamental features of the hotel were removed in compliance with the simple lifestyle of the order. Jesuit professors published several religious books while at West Baden. The Jesuits owned the hotel until 1964. It sat empty for two years and was then acquired by a donor who gave it to Northwood Institute, which operated a college until 1983 on the property.

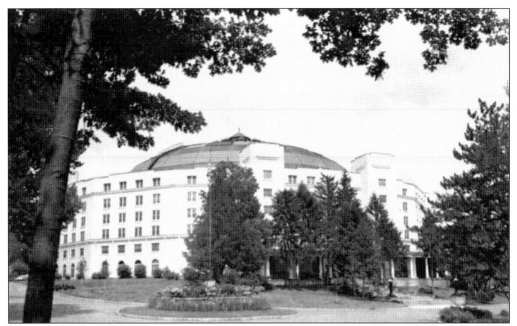

When the towers of West Baden College required repair, the Jesuits removed them. There are 30 Jesuit graves in a small cemetery adjacent to the hotel. The Jesuit Order retains ownership of the cemetery and continues to maintain it. The racehorse Peter the Great was owned by Ed Ballard and sired over 600 offspring. The racehorse is also buried on the grounds.

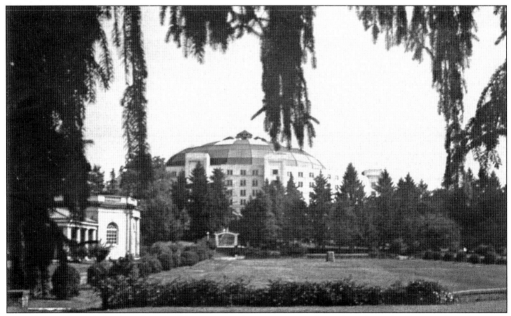

Northwood used the hotel as a self-contained campus. Students lived in the former hotel rooms and used other space for classes. The Northwood Institute used the hotel for its hotel management and culinary arts curriculum. It also offered other junior college courses. Automobile marketing was a popular curriculum.

Three

RECREATION
OPPORTUNITIES
GOLF BALLS, CLAY PIGEONS,
AND ELEPHANTS

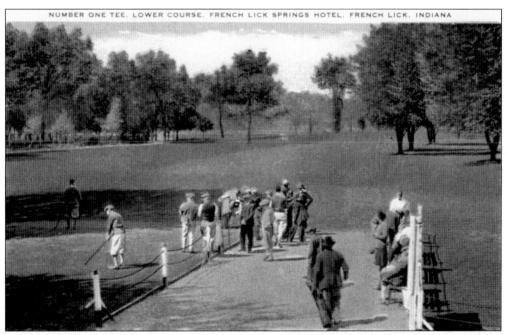

NUMBER ONE TEE, LOWER COURSE, FRENCH LICK SPRINGS HOTEL, FRENCH LICK, INDIANA

Both hotels had golf courses, but the French Lick Springs Hotel courses were of world-class caliber. Tom Taggart first built the Valley Course on 80 acres contiguous to the hotel grounds. Its original 9 holes were expanded to 18 in 1910. Knickers and long socks were appropriate clothing for the male golfers. Females wore skirts and long socks. The Professional Golf Association 1923 tournament was held at French Lick. It was won by Walter Hagen. The number one tee on the lower course at the French Link Springs Hotel is pictured above.

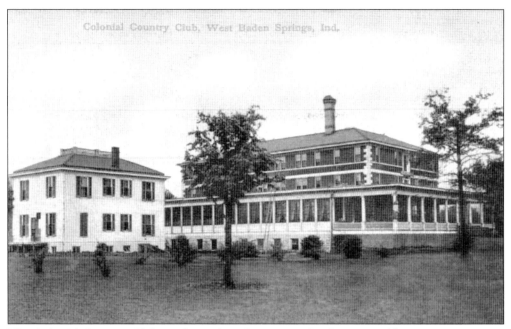

The Colonial Country Club was located on the West Baden Springs Golf Course.

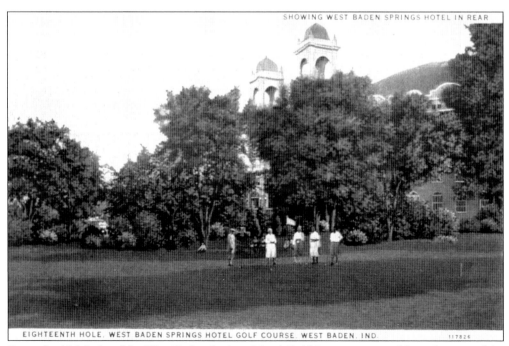

From the 18th hole of the West Baden Springs Hotel Golf Course, one could see the rear of the hotel. A golfer could tee off from the hotel's porch.

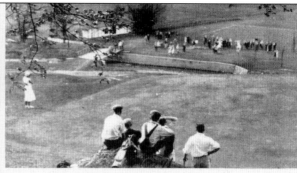

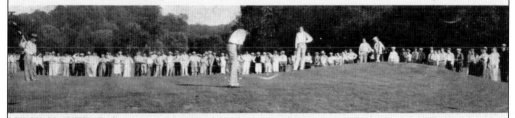
As this advertisement for the French Lick Springs Hotel illustrates, various diversions were available at the hotels, many of which were included in the room rate. Those with automobiles were provided with maps and directions to various points of interest in the area. Tennis could be played on grass or concrete courts. There were billiard and pool tables. Swimming was offered at the West Baden Springs Hotel natatorium with separate pools for men and women.

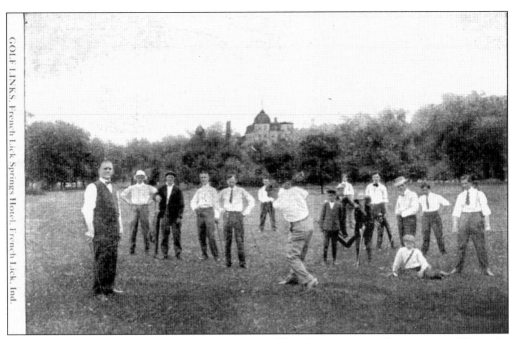

All the golfers on the French Lick Springs Hotel Golf Links are wearing long pants and bow ties or neckties. The young boys are caddies.

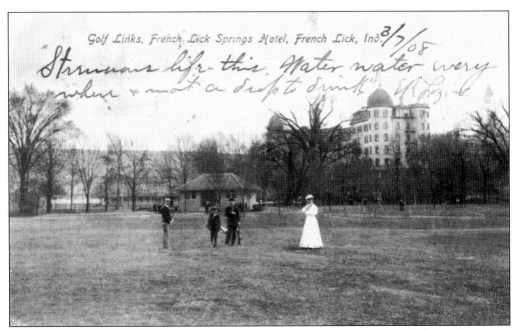

Golf Links, French Lick Springs Hotel, French Lick, Ind. 3/7/08

"Strenuous life-this. Water water every where + not a drop to drink"

This postcard depicting the French Lick Springs Hotel Golf Links is postmarked March 7, 1908, and is addressed to "Stevens Duryea Auto Agency" in Chicago. The message states, "Strenuous life – this. Water water everywhere & not a drop to drink."

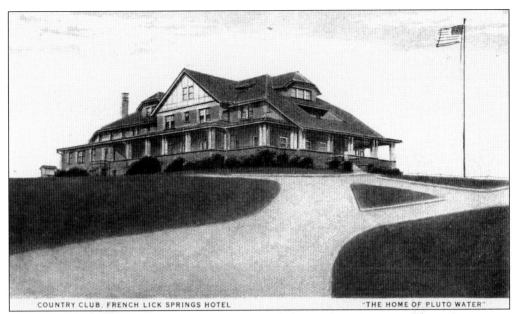

COUNTRY CLUB, FRENCH LICK SPRINGS HOTEL "THE HOME OF PLUTO WATER"

The French Lick Springs Country Club was on a hill west of the hotel. In 1920, the Taggarts built the Hill Course, which was designed by Donald Ross, the "father of golf course design." The course was par 70 with 6,777 yards of golf. Ross designed over 500 golf courses, including Pinehurst No. 2, Seminole, Duneden, Inverness, and Oak Hill.

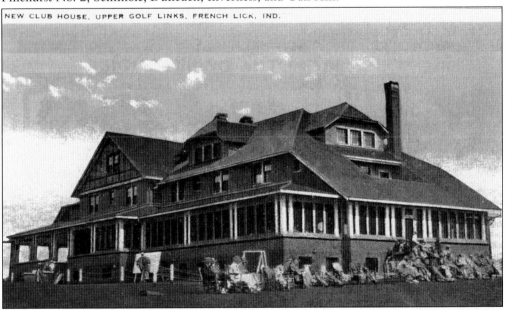

NEW CLUB HOUSE, UPPER GOLF LINKS, FRENCH LICK, IND.

The "upper course" was designed by Donald Ross and finished in 1920. The new clubhouse was elaborate with 30 sleeping rooms and 200 lockers for men and 35 lockers for women. There was also a dining room and bar. Ross's philosophy was to make golf a pleasure not a penance and to create a way for everyone to play the course. He said, "The Test should call for long and accurate tee shots, accurate iron play, precise handling of the short game and consistent putting. These activities should be called for in a proportion that will not permit excellence in any one department to largely offset deficiencies in any other."

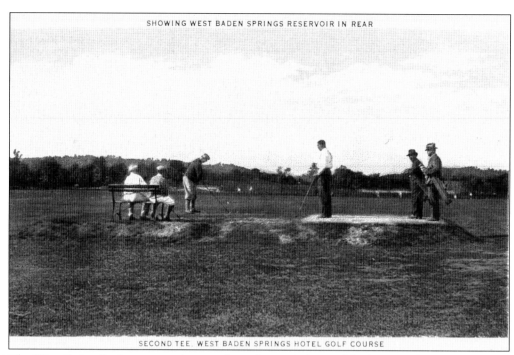

The West Baden Springs reservoir, seen from the second tee of the West Baden Springs Hotel Golf Course, provided a water hazard for golfers.

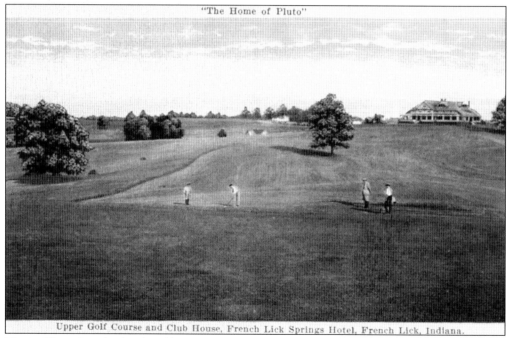

The rolling Cumberland Hills were ideal for a challenging golf course. The clubhouse is in the upper right of the image, which shows the upper golf course of the French Lick Springs Hotel.

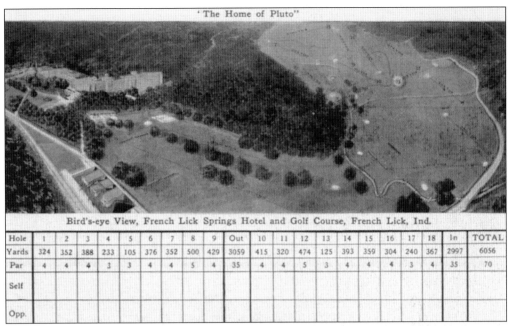

Bird's-eye View, French Lick Springs Hotel and Golf Course, French Lick, Ind.

Hole	1	2	3	4	5	6	7	8	9	Out	10	11	12	13	14	15	16	17	18	In	TOTAL
Yards	324	352	388	233	105	376	352	500	429	3059	415	320	474	125	393	359	304	240	367	2997	6056
Par	4	4	4	3	3	4	4	5	4	35	4	4	5	3	4	4	4	3	4	35	70
Self																					
Opp.																					

This bird's-eye view shows the French Lick Springs Hotel and Golf Course. The golf course had 18 holes, 6,056 yards, and was par 70.

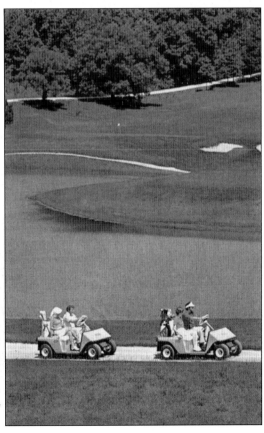

At the French Lick Springs Golf and Tennis Resort, golf carts and paths were demanded by modern golfers.

An investment in
REST and RECREATION

The sunshine is warm, the grass is green, the weather's fine at French Lick Springs. Come now. Play and rest; recuperate from the trials of winter.

FRENCH LICK SPRINGS

At this season thousands yearly visit French Lick Springs, the home of Pluto Water. The Cumberland foothills are radiant now with Springtime's early awakening. The air is a tonic in itself. Golf and tennis are in full swing. There are two 18-hole golf courses; one of them, opened recently, is the finest in the country. Riding, hiking and other outdoor sports.

Come now. Rest and play. Drink Pluto Water as it comes gushing from the ground, and take the world-famous medicinal baths. Large, fireproof hotel; excellent food; music, dancing — every provision for comfort and enjoyment. A trip now to French Lick Springs will pay you dividends in better health during the months to come.

Wire or write for reservations. French Lick Springs is conveniently reached via the Monon and Southern Railroads. Open all the year.

SEND FOR BOOK OF VIEWS
On request we will send a beautifully printed 48-page book descriptive of French Lick Springs and the French Lick Springs Hotel. Contains 62 actual photographs; large colored panoramic view of hotel, grounds, and two golf courses; 16 views taken on golf courses. We will also send rates and other information. Write today—address Department 10.

FRENCH LICK SPRINGS HOTEL CO
Dept. 10, French Lick Springs, Indiana
THOMAS D. TAGGART, *President*

The Home of Pluto Water

This full-page advertisement appeared in the *Literary Digest* for March 1, 1922. Besides eating, bathing, and attending the spas, there were plenty of diversions at the hotel. If one was not interested in sports, there was also gambling.

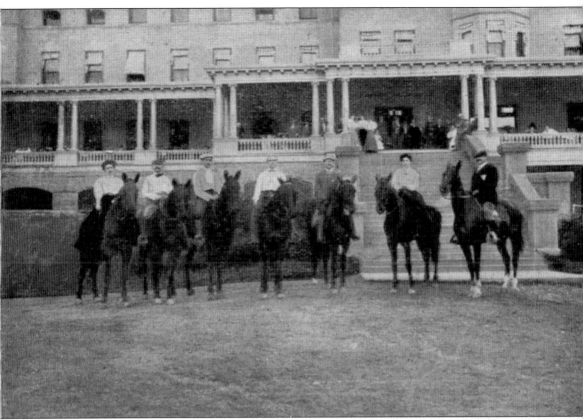

This postcard, portraying the "morning exercise" at the French Lick Springs Hotel, is dated May 24, 1907. The message includes, "I am feeling much better today than for two days. I hope I shall sleep well." A morning ride on the trails was a popular pastime. Tom Taggart Sr., Tom Taggart Jr., Lee Wiley, and Ed Ballard all had stables with quality racehorses. The Taggarts catered to the Kentucky Derby crowd, many of whom arrived in their private railroad cars, stayed at the French Lick Springs Hotel, and were taken to and from the derby on the Monon Railroad.

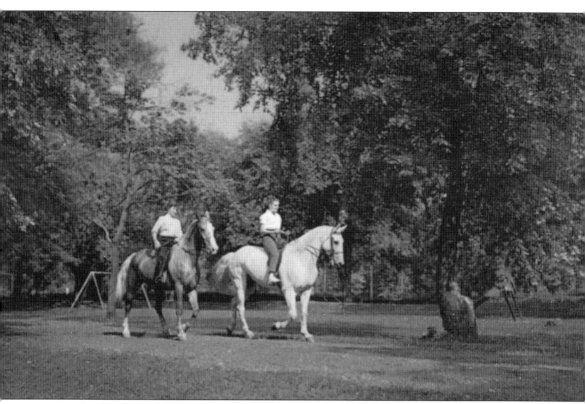

Horseback riding on over 50 miles of groomed trails at the Sheraton Hotel in French Lick continued to be popular. This image is from around 1960. Walking or jogging was also popular on the local trails or on the bicycle track, which was lit at night. The landscaped and meticulously manicured lawns and flower gardens invited leisure walks. Thomas Taggart once said, "The gardens are as good for your soul as are the sulphur baths for your aches and pains."

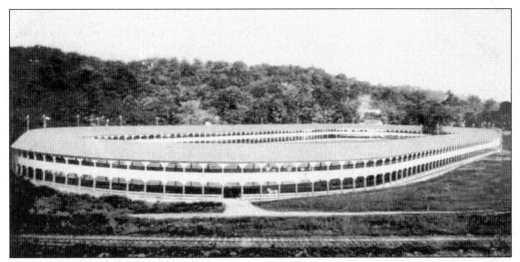

The Carlsbad of America covered cycle track was built in 1893; this huge wooden structure provided one-third of a mile of indoor cycling. The ground-level track was used for horses and ponies. The interior was a baseball field. Spectators could sit along the upper railing and have an excellent view of the game. The structure was destroyed by a tornado in 1927 and was not rebuilt.

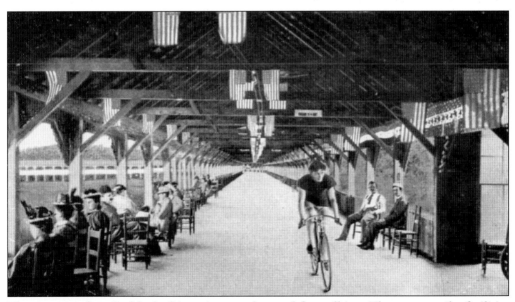

The upper track at Carlsbad of America was also used for walking. There were toilet facilities strategically located because of the physic propensities of Sprudel and Pluto Water. The upper track was lit at night for evening walks.

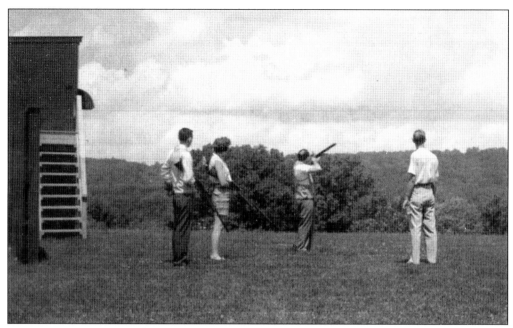

Skeet, trap, and target shooting were offered at the French Lick Springs Hotel. The Skeet and Trap Club is pictured above. One could bring his own gun or could use the ones provided. Instruction was also available. A clay "pigeon," actually a disc about eight inches in diameter, was thrust into the air from the tower on the left. The shooter attempted to hit the disc in mid-flight. The card states, "The Club is located on the hill to the rear of the Hotel. Beginners always welcome. Free lessons by instructor. Guns available at no charge."

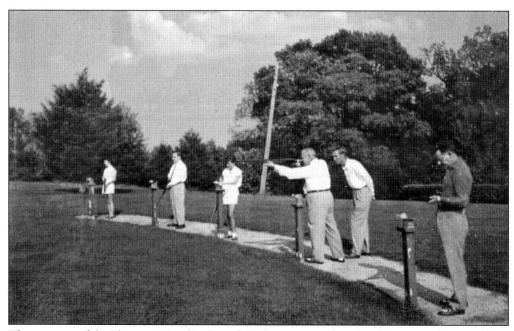

These guests of the Sheraton Hotel in French Lick are target shooting from a standing position. Boxes of shells are on the pedestals.

The Chicago White Sox traveled from Dearborn Station in Chicago to French Lick via the Monon Railroad. The team was in spring training at French Lick until April 12. The player roster from 1944 lists players in the armed forces of the United States, including one who "Died in Service" and one who was "Missing in Action." Several midwestern professional baseball clubs had their spring practice at French Lick-West Baden, including the Chicago Cubs, Chicago White Sox, Cincinnati Reds, St. Louis Browns (later Cardinals), Pittsburgh Pirates, and Philadelphia Phillies.

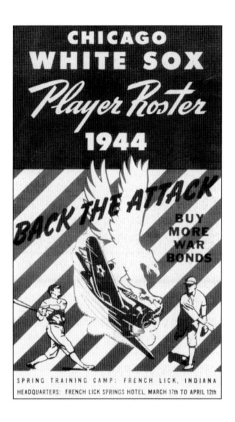

1944 EXHIBITION GAMES

Party Will Leave Chicago for French Lick, Ind. from the Dearborn Station, Thursday, March 16 at 9:15 P. M. via Monon R. R.

Sat.	Mar. 25	White Sox vs. Detroit at Evansville, Ind.
Sun.	Mar. 26	White Sox vs. Detroit at Evansville, Ind.
Sat.	Apr. 1	White Sox vs. Pittsburgh at Louisville, Ky.
Sun.	Apr. 2	White Sox vs. Pittsburgh at Louisville, Ky.
Thur.	Apr. 13	White Sox vs. Cubs at Wrigley Field, Chicago
Fri.	Apr. 14	White Sox vs. Cubs at Comiskey Park, Chicago
Sat.	Apr. 15	White Sox vs. Cubs at Wrigley Field, Chicago
Sun.	Apr. 16	White Sox vs. Cubs at Comiskey Park, Chicago

★

DOUBLE-HEADERS—1944

April 30th	St. Louis
May 28th	Boston
May 30th	Philadelphia
June 4th	Washington
June 11th	Detroit
June 25th	Cleveland
July 23rd	New York
July 30th	Philadelphia
August 6th	Detroit
September 4th	Detroit
September 10th	St. Louis

★

NIGHT GAMES—1944

Wednesday	May 24	with	New York
Monday	May 29	with	Boston
Friday	June 2	with	Washington
Wednesday	June 7	with	Detroit
Wednesday	June 14	with	St. Louis
Friday	June 23	with	Cleveland
Tuesday	July 18	with	Boston
Monday	July 24	with	New York
Thursday	July 27	with	Washington
Monday	July 31	with	Philadelphia
Saturday	Aug. 5	with	Detroit
Friday	Sept. 1	with	Cleveland
Thursday	Sept. 7	with	St. Louis
Tuesday	Sept. 19	with	Philadelphia

While the Chicago White Sox were in spring training at French Lick in 1944, they played exhibition games at Evansville and Louisville. Col. Lee Sinclair organized several local teams, including the Black Diamonds, which was made up from the ranks of African American waiters. Lee Wiley fielded an African American team known as the West Baden Sprudels, who played barefoot. Their manager was C. I. Taylor, who later purchased the well-known ABC (American Brewing Company) team. Taylor stocked the team with his brothers Ben, John, and Jim, who were among the best African American players in baseball.

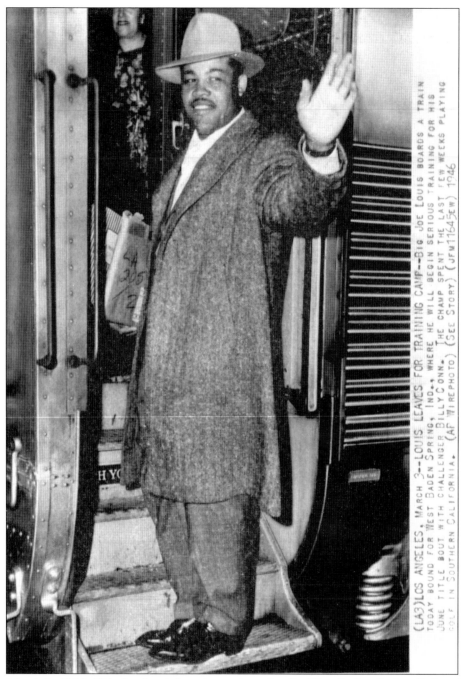

(LA3)LOS ANGELES, MARCH 3—LOUIS LEAVES FOR TRAINING CAMP—BIG JOE LOUIS BOARDS A TRAIN TODAY BOUND FOR WEST BADEN SPRING, IND., WHERE HE WILL BEGIN SERIOUS TRAINING FOR HIS JUNE TITLE BOUT WITH CHALLENGER BILLY CONN. THE CHAMP SPENT THE LAST FEW WEEKS PLAYING GOLF IN SOUTHERN CALIFORNIA. (AF WIREPHOTO) (SEE STORY) (JFM11543FW) 1946

On March 3, 1946, "Big Joe Louis boards a train today for West Baden Spring, Ind., where he will begin serious training for his June title bout with challenger Billy Conn. The champ spent the last few weeks playing golf in Southern California." The West Baden Springs Hotel was closed by this time. He likely stayed at the Waddy Hotel, which was "for blacks." In a 1941 bout, Conn led Louis for 12 rounds on all the scorecards but was knocked out by Louis in the 13th round. Conn became so celebrated in defeat that he starred in a Republic Picture film, *The Pittsburgh Kid*, later that year.

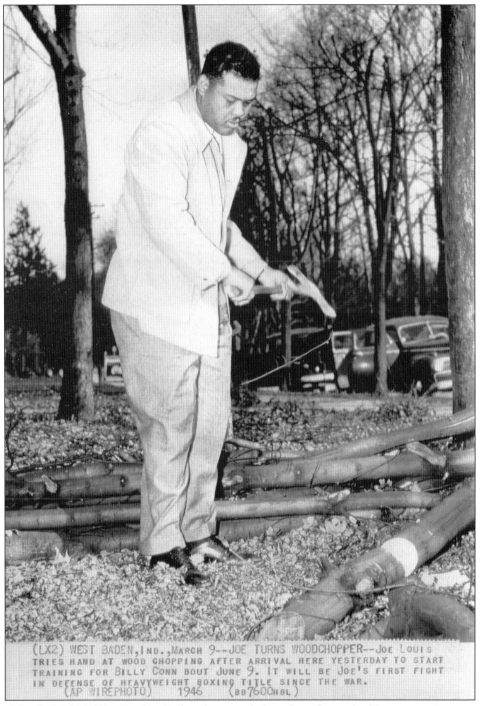

(LX2) WEST BADEN, IND., MARCH 9--JOE TURNS WOODCHOPPER--JOE LOUIS TRIES HAND AT WOOD CHOPPING AFTER ARRIVAL HERE YESTERDAY TO START TRAINING FOR BILLY CONN BOUT JUNE 9. IT WILL BE JOE'S FIRST FIGHT IN DEFENSE OF HEAVYWEIGHT BOXING TITLE SINCE THE WAR. (AP WIREPHOTO) 1946 (BB7600HBL)

On March 9, 1946, "Joe Louis tries hand at wood chopping after arrival here yesterday to start training for the Billy Conn bout June 9. It will be Joe's first fight in defense of heavyweight boxing title since the war." Both Louis and Conn had served in the military. Their rematch drew a gate of nearly $2 million, the second-largest gate in history. The "Brown Bomber" knocked out the "Pittsburgh Kid" in the eighth round in the 1946 rematch.

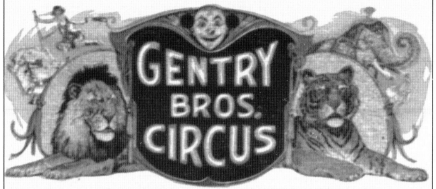

UNITED CIRCUS CORPORATION
Operating

GENTRY BROS. CIRCUS

Permanent Address: West Baden, Ind.

America's Largest Motorized Circus Transported
on 100 G. M. C. Trucks.

OFFICIAL ROUTE

June 30—Anderson, Ind. 32
July 1—Marion, Ind. 36
July 2—Bluffton, Ind. 42
July 3—Fort Wayne, Ind. 25
July 4—Napoleon, Ohio 66
July 5—Monroe, Mich. 68

July 6 (Sun.)—Detroit, Vernon and Dixie H.

July 7—Wyandotte, Mich.

July 8—Detroit, Highland Park, Opp. Ford Pl.

July 9—Detroit, Mich., Highland Park

July 10—Detroit, Mich, Dexter and Glendale

July 11—Detroit, Warren and Leivernoise

July 12—Detroit, Mich., St. Aubin and Faber

July 13 (Sunday)—Detroit, Warren & Conners

FIRESTONE TIRES USED EXCLUSIVELY

This postcard is dated June 27, 1930, and addressed to Peru, Indiana. Ed Ballard owned the Gentry Brothers Circus, headquartered at West Baden. He also owned many other circuses under the American Circus Corporation corporate umbrella. His circus holdings exceeded Ringling Brothers until he sold out to Ringling just six weeks before the 1929 stock market crash. The Hagenbeck-Wallace and Gentry Circuses wintered at West Baden. At certain times of year, one could view the animals and sometimes see performers practicing.

Four

THE SPRINGS
PLUTO WATER AND SPRUDEL WATER

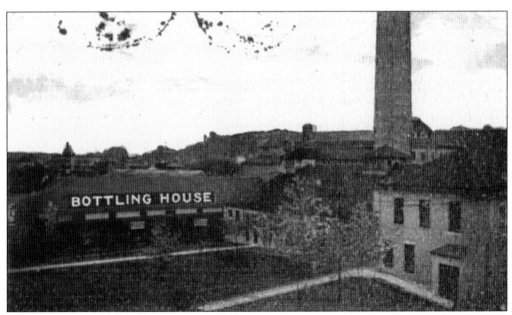

This postcard from the French Lick Springs Hotel is postmarked August 28, 1907, and reports that the sender "Arrived safe and am quartered at the Wells Hotel." There were numerous spas throughout Indiana in 1900. In 1901, the Indiana Department of Geology and Natural Resources identified over 150 mineral springs in 52 counties.

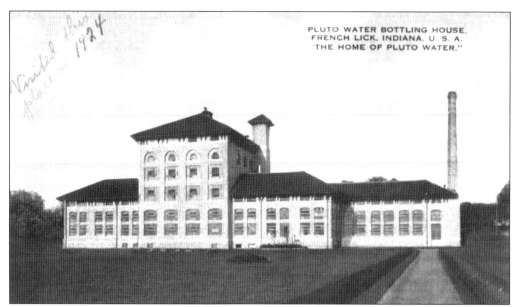

This image shows the Pluto Water bottling house around 1924. Pluto Water was bottled and sold nationally in drugstores. Every bottle of Pluto Water advertised the French Lick Springs Hotel Spa. The French Lick Springs Hotel advertised the water extensively and claimed it was helpful for "diseases of the stomach, intestines, liver, gall bladder and ducts, auto-intoxication (toxins in the system), intestinal indigestion, gout, rheumatism, diabetes, obesity, under nutrition, diseases of the blood, diseases of the heart and blood vessels, diseases of the urinary system, diseases of the skin, and diseases of the nervous system."

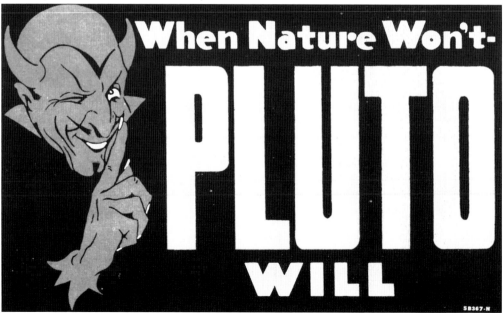

"When Nature Won't – Pluto Will." A wag retaliated, "If Pluto won't, make your will." The mineral content in Pluto Water assisted with bowel movements. The French Lick Springs Hotel modestly claimed that the water was not advisable for weak heart action or shortness of breath, dropsical conditions, advanced kidney disease, and arteriosclerosis.

Claims of curative powers were unregulated. Brochures for the West Baden Springs Hotel stated that their springwaters could cure amenorrhea, bladder disease, blood diseases, Bright's disease, bruises, catarrh, chlorosis, constipation, corpulency, debility, dysentery, dysmenorrhea, dyspepsia, eczema, erysipelas, eye diseases, female complaints, gall stones, gastritis, gout, hives, indigestion, influenza, insomnia, intemperance, jaundice, kidney disease, LaGrippe (and resultant evils), leuchorrhea, liver complaint, malaria, mucous membrane troubles, neuralgia, obesity, paralysis, piles, pimples, quinsy, rheumatism, scrofula, sick headaches, skin disease, sprains, sterility, syphilia, tetter, urinary troubles, venereal diseases, and white swellings.

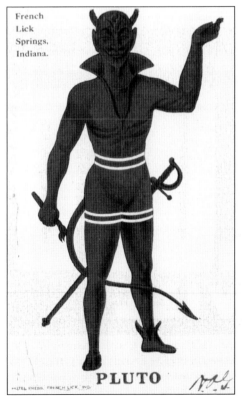

French Lick Springs, Indiana.

PLUTO

While the image of Pluto looks like the devil, it was intended to depict the Roman god of wealth and riches. In mythology, Zeus blinded Pluto and Plutus, his double and the god of agricultural riches, so that he might distribute his bounty without prejudice. Even after recovering his eyesight, he continued to bring wealth to honest men only. The statues located at the hotel are also sightless.

Baths

All of the usual hydropathic procedures such as Turkish, Russian and Electric Light baths, the various douches, shower and spray treatments, wet and dry packs, etc., are administered by competent attendants under careful supervision, but the Sulphur bath is, so to speak, the staple bath of French Lick. It is these baths, together with the waters, which form the basis upon which the reputation of this resort has been built.

This 16-page, *c.* 1910 pamphlet was written by George D. Kahlo, M.D., medical director of French Lick Springs and also professor of medicine at Indiana Medical College.

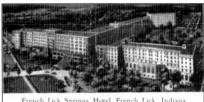

French Lick Springs Hotel, French Lick, Indiana

French Lick Salts

FROM FRENCH LICK, INDIANA

America's Famous Spa

Nature's saline springs which bubble up from the cavernous depths under the Cumberland foothills, at French Lick, in southern Indiana, are famous the world over. Every year thousands come from far and near to partake of these health giving waters.

But everyone in need of these marvelous laxative waters cannot come to French Lick. French Lick Salts brings the same health benefits to you.

French Lick Salts contains all the essential and important properties found in these highly mineralized therapeutic water . . . in a handy-sized package . . . inconspicuous . . . convenient to carry or keep . . . and pleasant to take.

POSITIVE IN ACTION
PLEASANT AS JUNE
EFFERVESCENT AS YOUTH
GENTLE AS A MOTHER'S TOUCH
PRESCRIBED BY PHYSICIANS FOR MEN,
WOMEN, AND CHILDREN
FRENCH LICK SALTS

50c

The bath department at French Lick Springs Hotel offered every form of spa treatment available anywhere. There were tables for Aix, Vichy, Scotch, fan, rain, circular, steam, and perineal douches; Turkish and Russian rooms; rooms for colon irrigation and massages; Nauheim tubs; sulphur baths; dry and wet packs; enemata; and rubdowns with salt, alcohol, cocoa butter, and oil.

How to Slenderize the French Lick Way was written by William Edward Fitch, M.D., medical director of the French Lick Springs Hotel, and published in 1931.

This lithograph is from stationery provided to guests at the French Lick Springs Hotel. Despite the other spas within a few hundred miles, no spa rivaled the West Baden Springs and French Lick Springs Hotels in Orange County. The flamboyant owners, Tom Taggart and Lee Sinclair, were not bashful in their curative claims and in their very real opulent facilities. While they were competitors, their respective spas fed on each other. The Monon Railroad in conjunction with connecting lines, the Baltimore and Ohio and Pennsylvania, advertised the easy access to these spas via railroad.

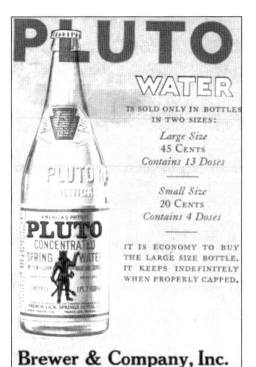

Pluto and Sprudel waters were bottled and sold nationally. Pluto Water was reduced to salts to which water was added by the consumer for use.

Physicians were given prescription pads to prescribe Pluto Water.

This advertisement for Pluto Water and the French Lick Springs health resort claims that Pluto Water can sure the ills of those "on the shady side of 50."

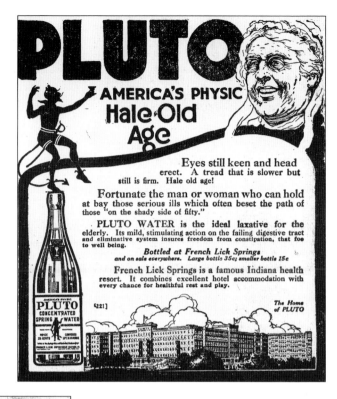

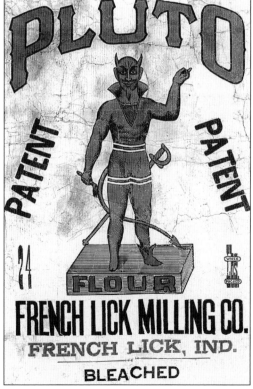

Pluto lent his name to flour as well, which was sold in 24-pound bags by the French Lick Milling Company.

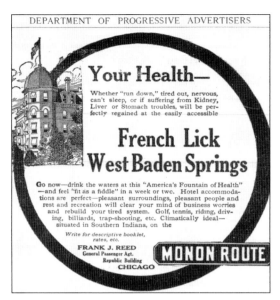

Your Health—

Whether "run down," tired out, nervous, can't sleep, or if suffering from Kidney, Liver or Stomach troubles, will be perfectly regained at the easily accessible

French Lick West Baden Springs

Go now—drink the waters at this "America's Fountain of Health" —and feel "fit as a fiddle" in a week or two. Hotel accommodations are perfect—pleasant surroundings, pleasant people and rest and recreation will clear your mind of business worries and rebuild your tired system. Golf, tennis, riding, driving, billiards, trap-shooting, etc. Climatically ideal— situated in Southern Indiana, on the

Write for descriptive booklet, rates, etc.

FRANK J. REED
General Passenger Agt.
Republic Building
CHICAGO

MONON ROUTE

This Monon Railroad advertisement implores the reader, "Go now – drink the waters at this 'America's Fountain of Health.'" The West Baden Springs Hotel had four sulphur springs. Spring No. 7 produced 12 gallons per minute. Nine different baths were offered in the men's saloon at West Baden: Electric light bath, mud bath, Turkish bath, Russian bath, West Baden Turkish bath, sulphur bath, shampoo bath, alcohol rub, and salt rub. Dr. Maximilian Lund, formerly of the German Army and bodyguard to the King of Saxony, was in charge of the men's bath. One of the ballplayers said, "If you go into the saloon with sore muscles, Maximilian will put you through such a workout that by the time you leave, you'll forget where the muscle was."

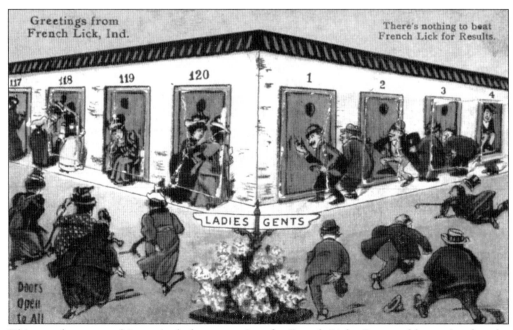

This novelty postcard is particularly appropriate for French Lick. One could surmise that the people in the image just drank a big dose of Pluto Water and are rushing to the toilet facilities. The various doors open, showing a person "doing his business," as in door No. 4.

Five

TWISTING THE
TIGER'S TAIL
GAMBLING IN THE HEARTLAND

French Lick and West Baden became as noted for gambling as for their spas. While gambling was not legal in Indiana, the Hotel Clifton housed a casino on the French Lick Springs Hotel grounds at an early date. Col. Lee Sinclair established a casino in the West Baden Springs Hotel in 1895. Many famous and notorious guests favored French Lick and West Baden. John Dillinger, Hopalong Cassidy, the Marx Brothers, Cole Porter, Diamond Jim Brady, and Al Capone were said to have gambled in the many clubs.

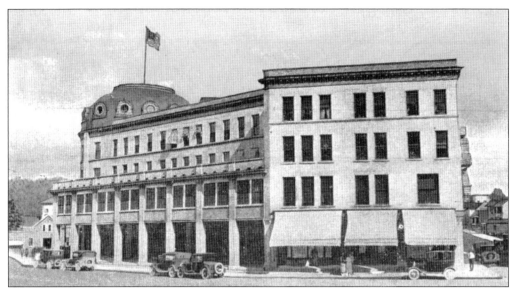

The Brown Hotel was across the street from the French Lick Springs Hotel and shared its heating system. It housed a casino, which was illegal in Indiana but tolerated until 1949, when it was ordered closed by Democratic governor Henry Shricker. The author recently asked a longtime resident of French Lick–West Baden why the gambling was stopped in 1949. In a soft southern drawl, she replied, "Honey, he was the first honest governor we had for a long time!"

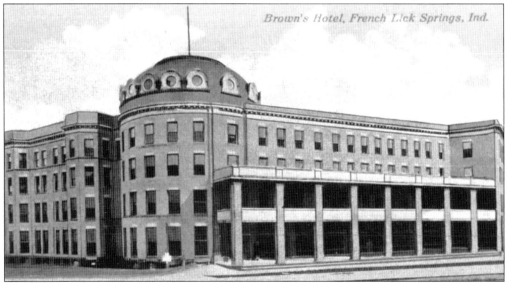

Ed Ballard was a bartender in a Paoli tavern. As in many Indiana taverns, there was a continuous poker game in the back room. The industrious Ballard soon owned the bar. He then took a job at the Dead Rat Saloon in West Baden, which he soon acquired. Thomas Taggart recognized the business talent of Ed Ballard and recruited him to operate the Brown Casino. Because of his high political profile, Taggart held his gambling operations at arm's length. Taggart was a prominent Democrat, and Ballard was a prominent Republican. Their political connections, the isolated location of Orange County, and perhaps a little cash distributed to the right public officials enabled the casinos to operate with impunity. Thomas Taggart Jr. died in 1946, ending the political protection for gambling.

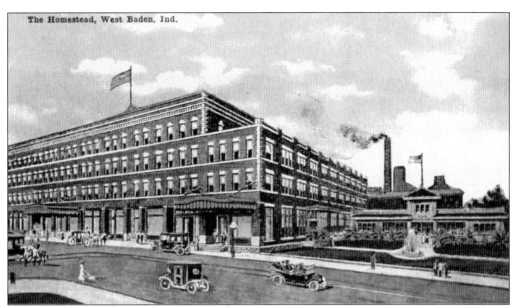

The Homestead in West Baden, owned and operated by Ballard, housed the Homestead Club. The annex on the right was called the sun parlor. After the original West Baden Springs Hotel was closed, the Homestead Hotel was renamed the West Baden Springs Hotel.

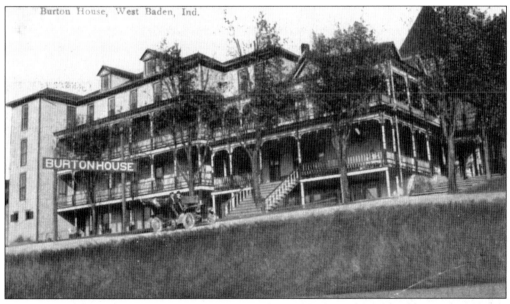

This postcard from the Burton House in West Baden is dated April 7, 1909. The sender reports, "We are at the jumping off place. Wife is writing for me as I have not been well since leaving Florida. It is my old trouble. This place, as you perhaps know, is quite a supreme resort for wealthy people. There are several kinds of mineral springs here." The Burton House operated a casino.

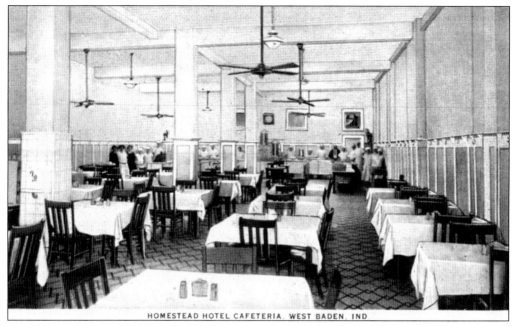

HOMESTEAD HOTEL CAFETERIA, WEST BADEN, IND.

The Homestead Hotel cafeteria in West Baden was probably somewhat less expensive than other hotel restaurants. Most of the staff members in the background are African Americans.

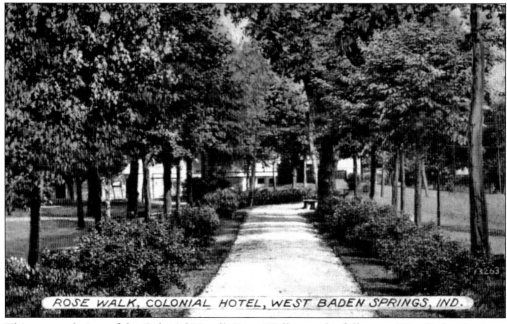

ROSE WALK, COLONIAL HOTEL, WEST BADEN SPRINGS, IND.

This postcard view of the Colonial Hotel's Rose Walk uses the full name West Baden Springs, even though the post office was just West Baden.

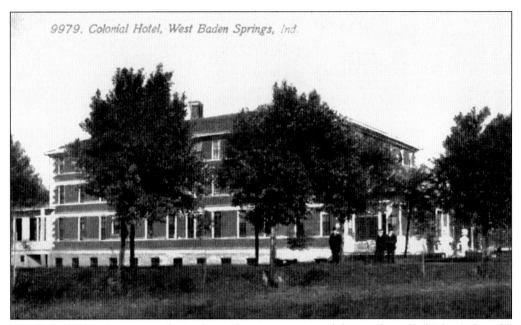

9979. Colonial Hotel, West Baden Springs, Ind.

The Colonial Hotel was popular in the mid-price range. Its club was also called "the Colonial." Over the years, many clubs called French Lick and West Baden home—Elite Club, the Brown, the Gorge, Hoosier Club, Chateau, the Mansion, Brown Club, Homestead, Roundtop Inn, Sutton House, Oxford Hotel, Ritter House, Colonial Club, Indiana Club, and Kentucky Club.

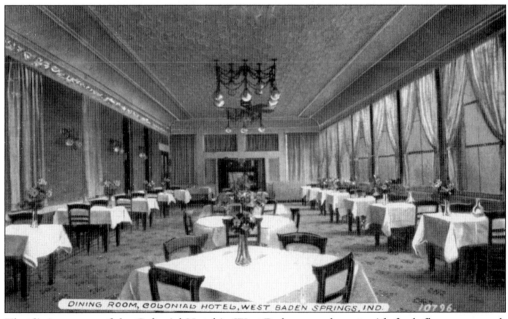

The dining room of the Colonial Hotel in West Baden was elegant with fresh flowers on each table and an elaborate chandelier.

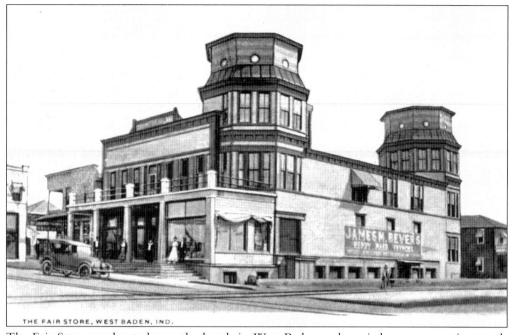

THE FAIR STORE, WEST BADEN, IND.

The Fair Store was located near the hotels in West Baden and carried more expensive goods than would be expected in most Indiana towns.

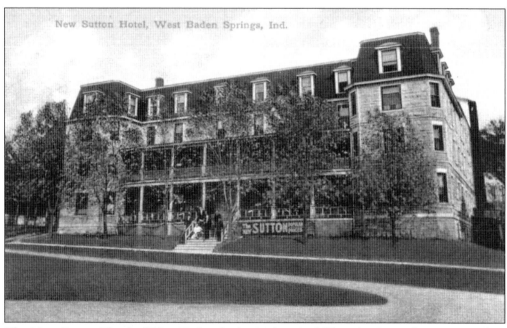

New Sutton Hotel, West Baden Springs, Ind.

The New Sutton Hotel of West Baden Springs advertised "Popular Prices." Rooms tend to be less expensive where there is gambling. Some gambling operations issued tokens in various denominations, which could be exchanged for merchandise. A 50¢ token could be spent for beer, cigarettes, or other merchandise. Since the gamblers were not using United States currency, they rationalized that they were not gambling. In fact, at the end of the night the tokens could be exchanged for cash. Many Indiana sheriffs looked the other way at this ruse.

The Gorge Inn was located in the countryside near French Lick and was surrounded by landscaped lawns. It was owned by Ed Ballard and also housed a gambling operation. It was an elegant supper club and casino. The menu included steak and chicken dinners served with fine china, silver flatware, and linen tablecloths.

LAKE AT THE GORGE, FRENCH LICK, INDIANA

The lake at the Gorge in French Lick attracted guests who wanted to take a scenic walk.

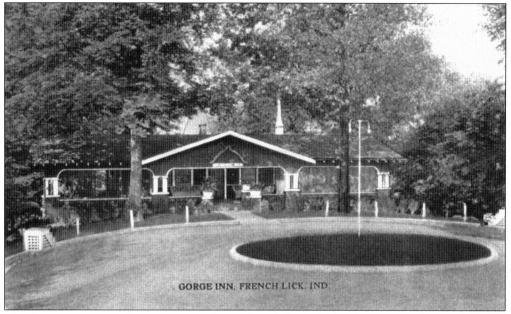

GORGE INN. FRENCH LICK, IND.

The front entrance to the Gorge Inn of French Lick looked like the entry to a pleasant home. There are ox yokes above the front steps. Note the small platform with steps on the left. The platform and steps were used to get in or out of a horse-drawn carriage.

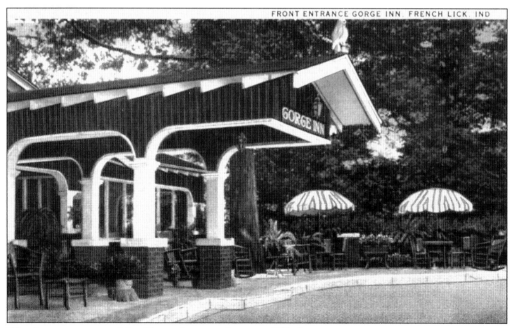

FRONT ENTRANCE GORGE INN. FRENCH LICK. IND

The front entrance of the Gorge Inn was later modified.

This view of the dining porch reveals that the interior of the Gorge Inn was in the mission style popular in the 1920s.

There were many mineral springs in the vicinity. Postcards depicting winter scenes, such as this view of Jacobs Spring at the Gorge in French Lick, are unusual.

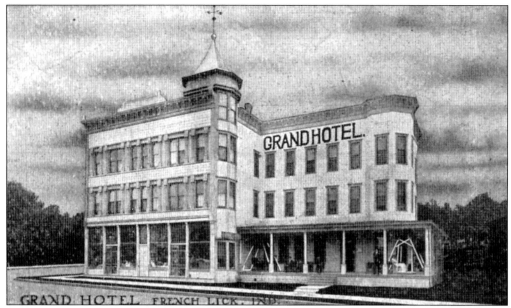

On the back of this view of the Grand Hotel in French Lick, the sender reported, "This is the Hotel we are at – not so many here . . . I am taking Electric baths for my limbs." Many of the lesser hotels had spa facilities. The lesser hotels in the valley included the Arlington, the Avenue Hotel, the Brown Club, the Burton House, Chateau, the City Hotel, the Claxton, the Colonial Club, the Elite Club, the Ellis, the Erwin, the Gorge Inn, the Grand, the Grigsby House, Homestead, Hoosier Club, the Howard, Indiana Club, Kentucky Club, the Lindly Inn, the Mansion, Oxford Hotel, the Perrin House, the Ritter House, the Roundtop Inn, the Ryan Hotel, the Southern, Sutton House, the Toliver, the Waddy, the Wells Hotel, and the Windsor. The various hotels provided a range of prices and amenities. The Monon Railroad advertised that there were over 2,900 rooms available in French Lick and West Baden.

The Maples: A Wayside Inn was located on U.S. 150, near French Lick and West Baden Springs. A card describes the inn, "Built in 1841 – a Stage-coach Inn on the New Albany – Vincennes turnpike – a famous landmark of Southern Indiana. The house has been redecorated, retaining the charm of the old Inn and now open for over-night guests and breakfast."

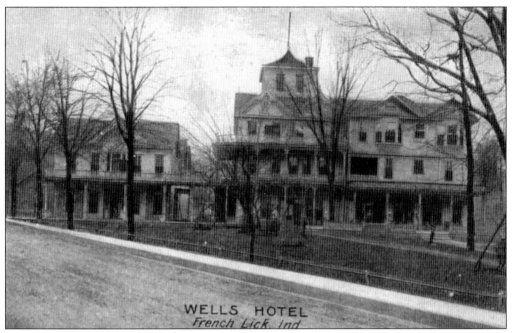

WELLS HOTEL
French Lick. Ind

This postcard picturing the Wells Hotel in French Lick is dated February 4, 1914. The sender says, "Dora is not quite so well but will be back in a day or two."

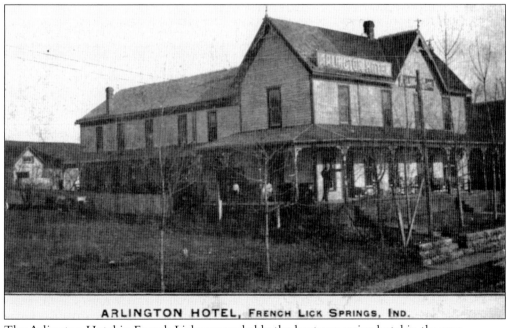

ARLINGTON HOTEL, FRENCH LICK SPRINGS, IND.

The Arlington Hotel in French Lick was probably the least expensive hotel in the area.

MT. ARIE

THE HIGHEST POINT IN INDIANA, WEST BADEN, IND.

The Mount Arie Tower was located on the highest hill west of the West Baden Springs Hotel. This postcard is dated March 30, 1909. Tom Taggart built a mansion on the top of Mount Arie. The home was identical to his home at Hyannis Port, Massachusetts, which was adjacent to the Kennedy family compound, except the eastern house was of frame construction while the Mount Arie structure was made of brick.

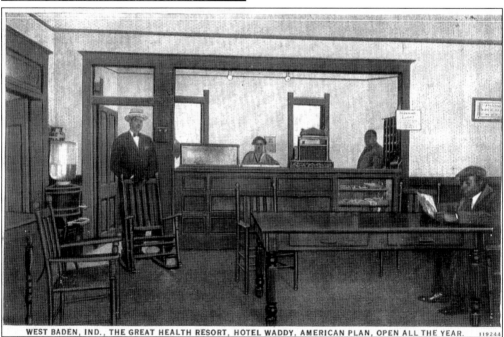

WEST BADEN, IND., THE GREAT HEALTH RESORT, HOTEL WADDY, AMERICAN PLAN, OPEN ALL THE YEAR. 119244

The Hotel Waddy in West Baden catered to African Americans. Generally African Americans were not welcomed in the other hotels; although they were the staff at most of the hotels. Joe Louis stayed here while he trained for the 1946 boxing match with Billy Conn.

Six

GETTING THERE
THE MONON CONNECTION

UNION DEPOT
FRENCH LICK, IND.

In an era when most travel was by rail, railroad connections to and from French Lick and West Baden were essential for prosperity. In the early years most guests arrived by rail. They were met at the Union Depot in French Lick by a horse-drawn hack from the hotel of their choice. In 1888, the French Lick Springs Hotel signed a contract with the Louisville, New Albany, and Chicago Railroad—the Monon—granting right-of-way onto the hotel grounds. The passenger car on the left is probably a private railroad car.

The Monon Depot at French Lick–West Baden was one of the grandest structures on the Monon. The Monon brought thousands of guests to the hotels. At its peak, 12 trains served French Lick and West Baden Springs Hotels on a daily basis. Sleeping cars arrived daily from Chicago and eastern cities.

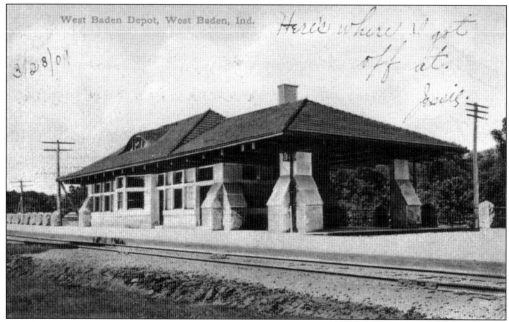

Into the 1930s, the Monon and Pennsylvania Railroads jointly operated through Indianapolis–French Lick service. Many trains traveled the French Lick–West Baden branch, particularly on Kentucky Derby weekends, when they arrived with surprising frequency. This postcard view of the West Baden Depot is postmarked March 23, 1909. The sender states, "Going out now for 2 more cold ones and a race to French Lick."

The wooded path leading to the depot in French Lick provided a pleasant place to walk.

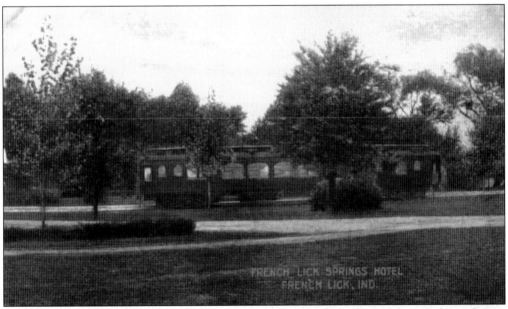

Only the wealthiest guests could afford to have their own private railroad car for travel. They were usually equipped with sleeping quarters, a dining room, a galley, and toilet facilities. They were frequently coupled to the end of a passenger train. This postcard view of the French Lick Springs Hotel is postmarked 1908 and contains an advertisement titled "A Drugless Cure." Thomas Taggart Jr. owned a racehorse named Peter the Great. Many horse race fans stayed at the French Lick Springs Hotel and rode special Monon trains to the Kentucky Derby.

115

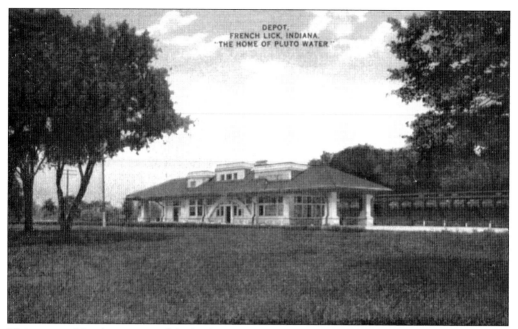

DEPOT,
FRENCH LICK, INDIANA.
"THE HOME OF PLUTO WATER"

This postcard is a later view of the backside of the depot.

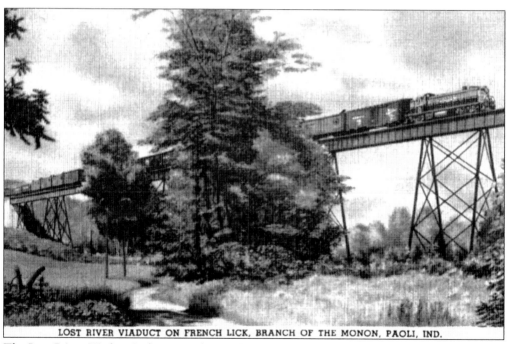

LOST RIVER VIADUCT ON FRENCH LICK, BRANCH OF THE MONON, PAOLI, IND.

The Lost River Viaduct is shown in this card, which was printed for Monon. The railroad ran throughout Indiana and connected Chicago to Louisville.

This print advertisement for the "Monon Route" discusses the many fine amenities in French Lick for tourists. Interestingly the local cure is recommended for both "over-work" and "over-play."

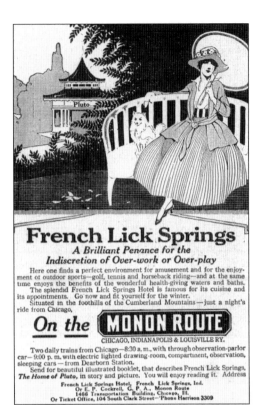

French Lick Springs
A Brilliant Penance for the Indiscretion of Over-work or Over-play

Here one finds a perfect environment for amusement and for the enjoyment of outdoor sports—golf, tennis and horseback riding—and at the same time enjoys the benefits of the wonderful health-giving waters and baths.

The splendid French Lick Springs Hotel is famous for its cuisine and its appointments. Go now and fit yourself for the winter.

Situated in the foothills of the Cumberland Mountains—just a night's ride from Chicago.

On the MONON ROUTE
CHICAGO, INDIANAPOLIS & LOUISVILLE RY.

Two daily trains from Chicago—8:30 a. m., with through observation-parlor car—9:00 p. m. with electric lighted drawing-room, compartment, observation, sleeping cars—from Dearborn Station.

Send for beautiful illustrated booklet, that describes French Lick Springs, *The Home of Pluto*, in story and picture. You will enjoy reading it. Address

French Lick Springs Hotel, French Lick Springs, Ind.
Or E. P. Cockrell, G. P. A., Monon Route
1466 Transportation Building, Chicago, Ill.
Or Ticket Office, 104 South Clark Street—'Phone Harrison 3309

This is a stock certificate for 100 shares in the Monon Railroad, which ran the Hoosier Line in Indiana. The certificate was made out to Tucker Anthony and R. L. Day and dated May 31, 1966.

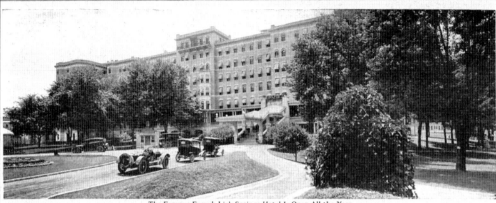

The Famous French Lick Springs Hotel Is Open All the Year

FRENCH LICK SPRINGS, IND.

In the protecting foothills of the Cumberlands, amid a wealth of natural scenery, is the French Lick Springs Hotel, the home of the famous Pluto Water. Long before the hotel was built, these springs were known for their extraordinary curative properties, and tradition is that the Indians would visit this spot to drink of the wonderful waters.

French Lick Springs affords all the pleasure to be enjoyed at a vacation resort, combined with the health-restoring advantages of the stimulating and rejuvenating waters and baths.

Before the hotel, lawns and gardens stretch over a lovely valley; to the left may be caught glimpses of the golf courses, dotted with golfers pursuing their favorite game; beyond rise wooded hills, cool and inviting. In the spring and fall, when one needs the assistance of a tonic and change of scenery, French Lick Springs is the place to visit, although it is an all-the-year-around resort.

Passengers may reach French Lick Springs via the Baltimore and Ohio Railroad direct to Mitchell, Ind., thence a short train ride via the Monon Route to destination.

WEST BADEN SPRINGS, IND.

Also situated in the beautiful valley of Orange County, Indiana, but a few miles from French Lick Springs, is situated the magnificent West Baden Springs Hotel. This unique structure covers five acres of ground, surrounded by landscape gardens upon which the eye never seems to tire of gazing. The encircling hills, adorned with noble forest trees, further enhance the scene.

The springs, which have their source at unmeasured depths below the surface, are noted for their wonderful healing powers, and attract many people from the entire country annually. It is likewise an all-the-year resort; the mild climate and sheltered location of the hotel making it possible to enjoy outdoor life throughout the year.

Trains of the Baltimore and Ohio Railroad from St. Louis and the West, and Cincinnati and the East, make direct connection at Mitchell, Ind., with the Monon Route trains to this resort.

PAOLI LITHIA AND SULPHUR SPRINGS, IND.

These springs are situated near French Lick and West Baden Springs, and have the same direct train connections at Mitchell, Ind., from points on the Baltimore and Ohio Railroad. The pretty town of Paoli is supplied with amusements of various kinds, beside the benefits of the medicinal waters.

The Baltimore and Ohio Railroad connected with the Monon at Mitchell.

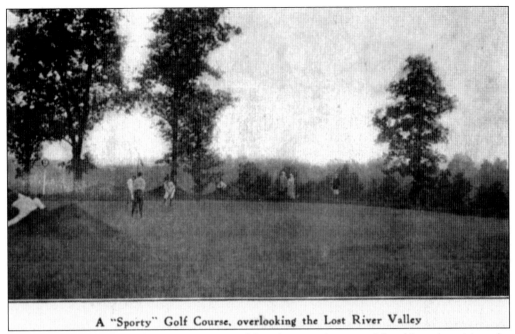

A "Sporty" Golf Course, overlooking the Lost River Valley

The view above comes from a promotional brochure and postcard booklet advertising the attractions of the West Baden Spring Hotel: "America's Most Famous Watering Place . . . In the Heart of the Hoosier Hills."

WEST BADEN SPRINGS, one of the most magnificent of American resorts, is located in a picturesque section of Southern Indiana. The hotel is wonderfully built and beautifully furnished, the service throughout is of high order, and the cuisine is unexcelled. All forms of out-door sports are found and the social life is delightful. The Mineral Waters are famous for conditioning properties, and the Bath Department is well equipped and directed.

AMERICAN PLAN - - - OPEN ALL THE YEAR
On the Monon and Southern R. R.

The brochure showed the Monon connections to other cities via rail. The Monon Route provided good rail connections from almost anywhere in the United States to French Lick and West Baden.

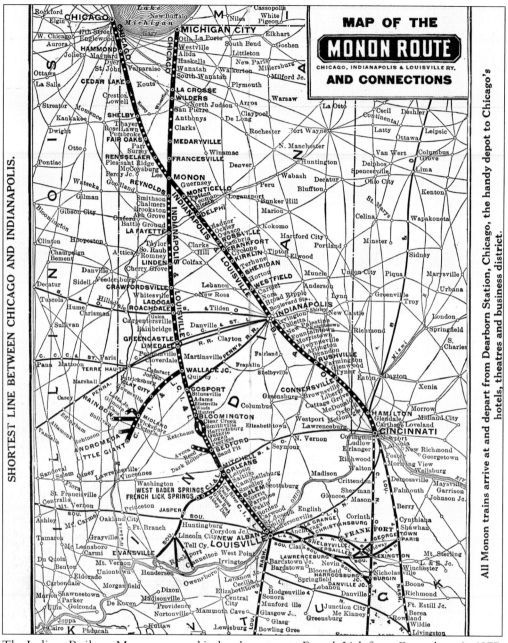

The Indiana Railway Museum moved its headquarters to French Lick from Greensburg in 1977. The facilities at French Lick included the limestone passenger station, a brick freight station, a large railroad yard for storage of rolling stock, a wye for turning equipment, and 16 miles of track, including a 2,200-foot tunnel. Excursion trains depart regularly from the depot. The railroad is known as "The French Lick West Baden & Southern Railway."

Seven

PAOLI AND ORANGE COUNTY
IN THE CUMBERLAND HILLS

The Orange County Courthouse in Paoli, built between 1847 and 1850, is the second-oldest courthouse in Indiana still in use. It is of Greek Revival architecture with a Doric portico, has six fluted columns made of brick and covered with concrete, and has stone caps. Orange County was organized by the Indiana Territory legislature in 1815 and named for Orange County, North Carolina, from whence many of the early settlers came. The stairs are made of ornamental iron, and the square cupola is capped with a bell-shaped roof.

WEST SIDE OF SQUARE, PAOLI, INDIANA

Paoli, the county seat, was platted in 1816. As with most Indiana county seats, the courthouse square, the west side of which is pictured above, is surrounded by business establishments and offices. Other towns in Orange County include Orleans, Chambersburg, Lost River, New Prospect, Orangeville, and Valeene.

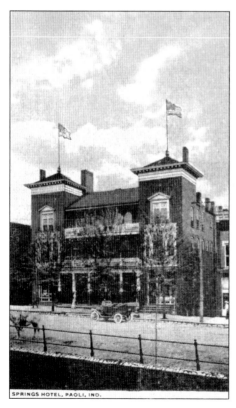

SPRINGS HOTEL, PAOLI, IND.

The handsome Springs Hotel with twin towers and flags flying was frequently used by guests who came to "take the waters" in the Paoli Area.

This card shows the Methodist church in Paoli. Note the distinctive stained-glass windows.

The Friends (Quaker) Church is of Classic Greek Revival architecture.

The post office in Paoli is located at 202 North Gospel Street and is of simple, functional design. The building contains a Work Progress Administrative (WPA) allegorical mural painted by Tom Post, a native of Richmond. The mural is oil on canvas and measures 12 feet by 5 feet 3 inches. The painting depicts a rural mail carrier in a closed buggy placing mail into a rural mailbox while greeted by the farmer, his wife, and his son. In the background of he mural, the Orange County Courthouse, the tall spire of the Friends Church, several of the taller buildings on the public square, the farmland of the surrounding countryside, and the industries and products of Paoli can be seen.

RICE'S PLEASANT VIEW MOTOR COURT, PAOLI, IND.

The back of this postcard indicates that the Pleasant View Motor Court is "modern" and is located two miles west of Paoli on U.S. 150, a major east-west highway through southern Indiana. French Lick and West Baden are a few miles south of this highway.

The Cider Mill in Paoli attracts tourists, offering beverages, baskets, and souvenirs to travelers on U.S. 150.

Paoli is nestled in the rolling hills of southern Indiana. The origin of its name is not clear, although it is theorized that it was named for Paoli Ashe, the son of Samuel Ashe, governor of North Carolina, who was named after his father's friend Pasquale Paoli, a Corsican patriot and general.

The brick structure seen in front of the Orange County Courthouse was a bandstand located on the roof of the police station. The metal tower supported the fire whistle, which summoned volunteer firemen to report to the fire station in the event of a fire.

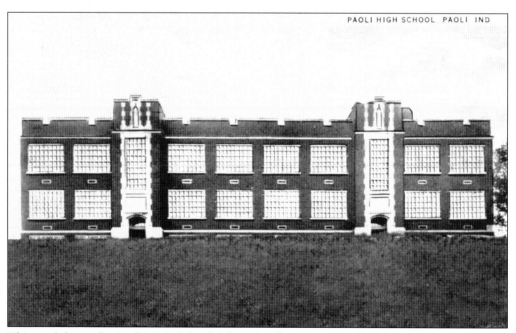

PAOLI HIGH SCHOOL. PAOLI IND

This card shows the Paoli High School. The school's mascot was the ram.

LIFE

Vol. 23, No. 25 December 22, 1947

SMALL TOWN NEWS

Indiana community has a lively week

PHOTOGRAPHS FOR LIFE BY PETER STACKPOLE

The 2,218 citizens of Paoli, down among the woods and creeks of southern Indiana, seldom get their names in the big-city newspapers. Like most small U.S. towns, Paoli is uniformly quiet, sober and law-abiding. Its citizens leave their front doors unlocked, and on Saturdays, when they double-park on the courthouse square, they leave the keys in their automobiles so that the man at the curb can get out. When Paoli does have a crime, the whole town is shocked, and usually a stranger is to blame (p. 21). Yet there is plenty of news—of the everyday sort that men really live by—in a town like Paoli. Every Thursday when the Paoli *Republican* comes out, almost all the townspeople, like the man at right, hurry to read it through from front page to last.

A pictorial account of the news the man is reading can be found on the following eight pages. For a full week, as the autumn turned to winter, a LIFE photographer followed the editor and reporter of the *Republican* as they made their rounds of Paoli seeking "items." His camera found scarcely anything that would have been worth more than a line in a city paper. But it did record a rich story of day-by-day events as they were lived not only in Paoli but also by the residents of thousands of other small American communities—by people who do not aspire to be very rich but seldom are very poor either, people who work hard and independently all week, fill up the small-town churches on Sundays and enjoy the simple and wholesome pleasures of the church social and the high-school supper.

WEEKLY EDITION of local paper is studied on the courthouse square by Justice of the Peace E. L. Throop. Like most of Paoli's busy citizens, he found considerable news of his own doings that week (pp. 16 and 20).

ON PAGE 81 OF THIS ISSUE THE DUKE OF WINDSOR CONCLUDES THE REMINISCENCES OF HIS YOUTH

Life magazine featured Paoli in its issue of December 22, 1947. A *Life* photographer followed the editor of the Paoli *Republican* for a week as he made the rounds seeking "items" to publish in the weekly newspaper. Highlights included a wedding performed by justice of the peace Troop, for which he charged $2; the birth of a new citizen; a divorce granted to a woman who testified that "her husband ran away with another woman;" a pauper funeral for an elderly hired hand whose 50 neighbors attended to hear him described as "a congenial, honest, toiler, with little thought to be a leader of men;" a turkey shoot; a card party where women played bridge and their husbands played poker; a pie supper where girls brought pies to auction—the highest bidder got the pie and got to spend the evening with the girl who baked it; a soldier who appeared in Orange Circuit Court to answer to a car theft; a basketball game victory attended by nearly the entire population of the town; and an incident where a man's hunting dog accidentally stepped on the trigger of his shotgun, causing the gun to fire and hit the hunter, this item titled "Frisky Pointer Fires Shotgun, Shoots Hunter."

127

Across America, People are Discovering Something Wonderful. *Their Heritage.*

Arcadia Publishing is the leading local history publisher in the United States. With more than 3,000 titles in print and hundreds of new titles released every year, Arcadia has extensive specialized experience chronicling the history of communities and celebrating America's hidden stories, bringing to life the people, places, and events from the past. To discover the history of other communities across the nation, please visit:

www.arcadiapublishing.com

Customized search tools allow you to find regional history books about the town where you grew up, the cities where your friends and family live, the town where your parents met, or even that retirement spot you've been dreaming about.